JERRY N UELSMANN
SILVER MEDITATIONS

Dedicated to my MOM and DAD who lovingly supported my many youthful follies, giving me a lot of room to grow in a house full of pets and projects. There are many smiling memories, from the attempts to purchase a pet skunk to the small cellar room where I made my first contact prints through my mom's glass pie plate.

JERRY N UELSMANN
SILVER MEDITATIONS

INTRODUCTION BY PETER C BUNNELL

A MORGAN & MORGAN MONOGRAPH

I would like to acknowledge the thoughtful and gentle assistance of Diane Farris whose belief in this project and my vision is deeply felt.

Morgan & Morgan, Inc.
Publishers
145 Palisade Street
Dobbs Ferry, New York 10522

International Standard Book
Number 0-87100-087-3
Library of Congress Catalog Card
Number 75-7850

Printed in the U.S.A.

Monograph Series Editor: Liliane De Cock
Typeset in Techno Light and
printed in Quadradot Lithography
by Morgan Press, Incorporated

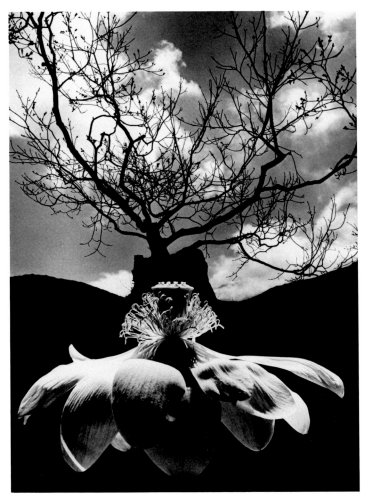

1968

Creators of Jerry Uelsmann's stature may be seen to have altered the language, the substance, and the direction of their art. He personally has been the recipient of considerable critical praise, though the general field of synthetic photography remains only cautiously embraced. Critics have been transfixed by the rational and the realistic in photography while the irrational and the imaginary have remained foreign to most. Present-day thinking about the medium is dominated by a naturalistic aesthetic and only a few individuals have encouraged the possibilities of separating and manipulating the syntactical structure of the *language* of photography. Most people still tend to think that when photographers make pictures they must depict objects and scenes that could, in principle, also be described in words. Photographs which appear to lack the assertive handiwork by which the artist has traditionally pointed to his invention are understood to be truly photographic, while artists in photography who employ varied and fundamental approaches to the synthesis of the medium are shunned. Uelsmann is, of course, of this latter rebellious breed and in his approach he strives for his senses to reveal, for his mind to re-create, a quintessential structure reflective of how he views the photographic process itself. In one sense his art may be considered conceptual; however, this is not wholly accurate for the otherness of the outside world is affirmed, not mitigated, by the intrusion of this artist's mind and hand.

The metamorphosis of ideas in photography is one of the most difficult aspects of the medium to understand. How a photographer such as Uelsmann searches for a significant image, first from the selection of the motif, then to the organization of forms, and finally to the combination of each in a picture in which the content is other than pure data is a kind of process magic-theatrical magic if the essence is the least bit irrational. This is no different from the process of creation in other media but it seems that photography has been dominated, in fact handicapped, by the failure of persons to recognize this conception of expression in the medium. So permeating has been the belief that photographs must be a form of vicarious experience of the subject itself that exceptions to this interpretation are rejected. A picture, properly appreciated, stands away from us as an object on its own — independent and complete. A division of the medium may be seen in which, on the one hand, images provide an imaginative and on the other a rational basis of experience.

Uelsmann's adherence to what he terms in-process discovery places him firmly in support of intuition. He affirms that there is no doubt that an important connection exists between his creative activity and dreaming. As the dream is an involuntary act of poetry, so the fortuitous selection and combination of negatives is the reflection of the imagination's independence of the will. In this sense Uelsmann's photographs, like dreams, have either no meaning or several meanings. Photographs freed from the scientific bias can, and indeed usually do, have double meanings, implied meanings, unintended meanings, can hint and insinuate, and may even mean the opposite of what they apparently mean.

Photographs have tended to be treated scientifically as a factual statement: "this is a person," "this is a shell," "this is a building." Contemplation in the face of such concrete things demands a great deal of the mind and the senses. Once one has recognized that

photographs have meaning, they become open to interpretation and characteristically several not mutually exclusive interpretations can be made of them. One has to add that most photographs are, usually, incomplete acts of visualization. Something still must be added to them before they can be transferred from the private sector of experience to the public, before they can acquire universality. This something-still-to-be-added must, I think, be more than just the translation of visual, nondiscursive imagery into coherent discursive photograhic language; in other words, the transformation of a dream or unconscious fantasy into a work of visual imagination cannot be analogous to the process of interpretation as practiced, for instance, by psychoanalysts. It must rather comprise the casting of the central meaning in symbols which are part of the shared iconography of the culture of which the artist is a member, and which, therefore, carry a heavy charge of shared, public associations and resonances. It is not that the artist actively masters the iconography of his times in order to be able to universalize his private emotions, but that one aspect of his capability is an exceptional sensitivity and receptivity to the iconographical network that constitutes the culture of his time that makes it natural for him to express his private emotions in universal terms, or perhaps not to distinguish between the individual and the universal, between the microcosm and the macrocosm at all. In this vein many persons superficially acquainted with Jerry Uelsmann and with his work have difficulty recognizing in him the ability to articulate the complex symbolism, which a number of writers, especially William E. Parker, have identified in his photographs. What I am suggesting is that while Uelsmann does have an inquiring, searching, and aware mind he is moreover exceptionally sensitive to the iconography of public expression. It is a fact that in photography there is a strong anti-literate sentiment which is most generally brought to bear against any photographer who is the least bit learned in his work. Such is clearly the case with Uelsmann and in his public appearances he often does little to challenge this notion. He is one of the few photographers to talk about his work with commitment and to have articulated a stylistic analysis of his own photographs, but I believe he stops short of verbalizing his awareness of iconology because he fears this very sentiment among his peers. No additional evidence of his ability to use his knowledge need be cited than the considerable body of photographs made over the last fifteen years which are indicative of his overall expressive achievement.

A necessary precondition of all imaginative activity seems to be what Keats called "negative capability," the ability to allow oneself to be "in uncertainties, mysteries, doubts, without any irritable reaching after fact and reason." In other words the ability to abandon the ideal of rational action and stop trying to master reality in favor of letting oneself happen. And, at least for such artists as Uelsmann, the execution as well as the conception of a work of art may also be largely independent of the will. In this it must be seen that all images reveal a psychic state.

In his approach Uelsmann has affinities to several artists in a variety of media. Like Joyce, for example, as he chooses to let his subjects dictate his methods rather than to impose a method upon his subjects. Uelsmann's description of his working procedures is

similar to Jackson Pollack's well known comment, "When I'm in my painting, I'm not aware of what I am doing." Like action painters Uelsmann sees the aim of art to be discovery, not the solving of formal problems. At work he proceeds until intuition informs him that a culmination has been reached which is the way abstract expressionist painters recognize that a painting is finished. One discovers what he has done afterwards. Art has to do with finding out something one did not know. This illustrates the fact that the imagination is autonomous of the will, of the self-conscious ego, and it is presumably the reason why poets and artists before the rise of psychology could believe literally in their inspiring Muse.

Uelsmann's process of self-revealment lies in the imaginative articulation of fragments. These fragments are the components of his existence experienced first, and partially, through the camera but it is as if he has not lived them until he sees them combined in pictorial form. Indeed he may also be seen to have now reached the state in his life where he projects these completed visions back on to reality itself. His self-confidence rests in his ability to synthesize knowledge outside of actual experience and his affirmation of in-process discovery is another way of saying that he values the revealment of autobiography. His pictures reflect a formal order, but their meaning is outside of the logic which confronts the rest of us in our everyday life. He is one of the very few to have depicted the Apocalypse. His work has been determined, in part, out of painful adolescent experience and tempered by the acceptance of the premise that the practice of art is rooted in life and that the felicity of art lies in its sustaining power. Humor, or perhaps more pointedly a kind of wit, has been one of Uelsmann's most characteristic qualities. On the surface it might be seen that this is reflective of his doing what he likes, but it is also reflective of a lingering suspicion that life is positioned by the potential of tragedy.

Minor White, whose aesthetic derives from Stieglitz's equivalent form, gave Uelsmann the realization of the poetic reality when he was a student at the Rochester Institute of Technology. Significantly, however, White by that time had extended Stieglitz's concept of equivalency through his own development of the corporate sequence of non-similar images. White draws freely from all fragments of his personal experience and recombines them into controlled autobiographical statements. This sense of control, through the combining of single photographs, and the interest in autobiographical expression, are key elements in White's contribution to the medium and in Uelsmann's subsequent extension of it through is own work. Autobiography is not necessarily in accord with fact and it may be seen to possess an immense potential for fiction and passion.

While Stieglitz organized his cloud photographs — images so photographic that they were true pictorial abstractions — into sequences or groups, the effect he sought was not so much to recreate experience as it was to allegorize his emotions. White, on the other hand, takes images which are more obvious or rational than abstract, and combines them into a kind of cinematic presentation heavily reliant on a varied repertoire of symbols which he believes can be "read" in photographs. The goal as White sees it is one of freeing the photographic experience from chronological time and making it into the totality of a life experience which has a cumulative meaning and identification greater

than any individual picture. Because of this method his pictures are frequently fragmentary in themselves and incomplete as allegory.

Uelsmann grasped this concept and has significantly modified it by adopting manipulative techniques which allow him to construct a non-linear sequence of images within a single picture. White, it must be pointed out, has always adhered to the stylistic purity of the straight photograph and his images reflect his strong and continuing solidarity with the group of Stieglitz, Weston, and Adams. Uelsmann, who by 1959 was now building on the encouragement of Henry Holmes Smith who placed a liberal emphasis on subjective creativity within the photographic process itself, sought to re-invent the process of picture making in photography by considering each camera negative as only *part of* of a single photograph. I use the word re-invent very particularly, because this is precisely the contribution made by Rejlander a hundred years before but which unfortunately has been lost today because of our inability to see his extraordinary invention beneath the sentiment or subject for which it was placed in service. Photographers like Uelsmann, Rejlander, White, and Stieglitz extended the concept of photographic time by replacing the finality of exposure time with a construct of conceptualized time as the basis for the experience of photographic reality.

The thought of incongruous juxtaposition was not, at first, an issue with Uelsmann and his early images are as pictorial in motif and motivation as are the photographs by the other three photographers mentioned above. Interestingly Uelsmann's observation on Rejlander's "Two Ways of Life" is that it is "an amazing image in that it is so intricately complex yet so infinitely resolved." Only gradually has he developed the ambiguous and more psychologically related experience where the expression of the irrationality of thinking and feeling is seen in both content and form. In recent years Uelsmann has admitted to not knowing what some of his pictures are about. I believe this is due to the fact that he has used single images within these photographs that came about through unrealized experience as early as the time of photographing when the continuum of recognition and reaction was incomplete and when his subconscious did not absorb and catagorize even the observable sensation. It is very much to the point in analyzing Uelsmann's working method that he does not consider using other persons's negatives. He will not borrow from the consciousness of others their visual fragments which are vividly different from what I have described as his life fragments in visual form. This methodology also relates to, and I believe clarifies, the issue of the symbolic construct of his pictures as discussed earlier. His sensitivity to the iconography of culture is manifested in the gesture of identifying his fragments in the field when photographing, and not only in the selecting of parts for a picture once in the darkroom. It is in this respect that he, like Manet, a counterpart in painting, may be seen to create after nature and it is why, after all the arguments about synthetic photography are said and done, Uelsmann is a photographer dependent upon the real world of primary observation.

Nevertheless Uelsmann also loves fantasy, and he uses it to carry a distinct moral. Literary art for him does not mean the mere teaching of moral truths, because whatever is

honestly worth seeing seems to him also capable of moral implication. His repititions of various images and themes is an emotional rhythm of testing propositions by refutations, as with bringing witnesses forward and cross-examining them. Like artists everywhere it is his aim not to find wisdom but to put it to work. He believes that reality has room for such models.

In contrast to his earlier pictures, Uelsmann's work in recent years has become less graphically dominating in terms of what may be seen as the relatively simple and harmonious counterpoint of objects and forms. Since about 1972 the picture space in his images has been filled in a more total and stressing fashion reflecting his own more complex psychic nature. He has reached the point where the work has turned in upon itself, where the mastery of craft has moved outside of illusion and conscious showmanship to a more introspective state of affairs where one can no longer tell so easily what is going on. I do not believe this is a matter of his technique becoming simply virtuosic, but rather that a fundamental change has occured in the work where the desire to exert any control over the artistic invention has been relinquished for the sake of creating images which exert control over his own life process in the hope of realizing something he feels is confused or incomprehensible. It is as if he is allowing the dream/image process to stabilize his own existence. Even today I do not believe we are at a point where this change has been concluded, though I sense a returning to his accustomed security which in the past has made his pictures more pictorial.

The dominating character and participant in Uelsmann's visual world is man. He is a humanist concerned with man's achievements and interests, with his actions and, as I have stated, with the moral implication of these actions. In many cases his pictures are singularly expressive of the sexuality of human interaction and he has mastered the presentation of erotic tension without yielding to pornography or resorting to non-objective symbolism. He uses the clothed or nude figure almost interchangeably. This is true not only with the female but we see it even more with his depiction of the male figure which does not appear naked but is almost always used as an expression of the anxiety and the primitive power of male sexuality. His rendering of the human figure is analogous to how one contrasts masks with illusion in the theater and it is clear that Uelsmann prefers the mask because it is frank; the figure in the mask is clearly an actor, not someone who is half-persuading you with grease paint and a wig that he is Othello.

Many persons, including myself, have been photographed by him and it is difficult to characterize these pictures. Portraiture is an easy label to assign to a large number of them, but it is not wholly satisfactory because Uelsmann's own dominating presence is never far below the surface of our own projection. When viewing our likenesses our composure is shaken by the realization that he has exempted us from the crowd and that we now must contemplate ourselves in a landscape which was not of our own choosing. The interpretation of these pictures will be largely individual when it is most clear that the emotive image is very particular, and when it is not the tendency is to take comfort and reach out for more universal interpretations.

Uelsmann is one of the few photographers who is not afraid to place himself before the camera. I believe that this is to intervene in his fantasy life, thus to assure his physical presence there, as well as a gesture to record for posterity the life process of aging-cum-maturing. Technically, Uelsmann's self-portraits are no different from his other compositions but in conception they are significantly different. His identification with his own being causes him to counter the independence of his will and to more fully conceptualize and control the image. In this way his self-portraits are extraordinarily reminiscent of the self-portraits of the pioneer Frenchman, Bayard or not unlike Stieglitz's shadow images of 1916 or Friedlander's recent photographs. These images are all compelling and rich because they are so dominated by a controlled psychological intensity. In portraiture we are always concerned with revealment, a quality which is frequently associated with perceptual truth. Uelsmann has admonished photographers to get out in front of the camera. Under his terms yes, but when he is photographed by others he is noticably reticent and inevitably a comic pose is assumed in gesture and expression. He is aware of what the camera can do. Not that any of us are not, but in his self-portraits, and likewise in his pictures of others, Uelsmann disarms us with the dark ambiguity between model and persona.

This is Uelsmann's second book and it brings together images primarily of the last five years. These photographs reinforce his position in the field, and as I said at the beginning of this essay, he clearly prefigured the contemporary direction of his medium. In so doing he has restored a tradition and acquired a position which relatively few of his generation can match. He has done this through a sustained endeavor and in measuring his work his failures must be seen to matter as much as the successes. It has only been in recent years that the public dedicated to photography has been able to map the continuous growth of its artists. Through many exhibitions and publications we have been in a position to follow this artist's work in depth as it has been created through incessant and thoughtful effort. In some respects this public awareness of him, which began at a very early point in his career, has had a profound effect on Uelsmann's own consciousness. There have been many public events, as his chronology shows, but the slow evolution and tempering of a maturing personality occurs more through private agonies and obsessions. All of these pictures do not have the instant appeal of certain of his earlier images which, both by quality and familiarity, are considered masterworks. These more recent images are less simple, more substantive, and in some cases dangerously close to contrivance or *voulu*. Certainly they are much less apt to amuse the viewer, but to be a master is to be a master. Uelsmann's innovation as an artist is in keeping with the multiplicity of his vision. There are pictures of his as perfect as anything in photography and emotions as clearly expressed as any in any medium. It is precisely in making the accomodation between self-confidence and humanity that makes his pictorial life so pleasurable for him and, ultimately, so challenging for us.

Peter C. Bunnell

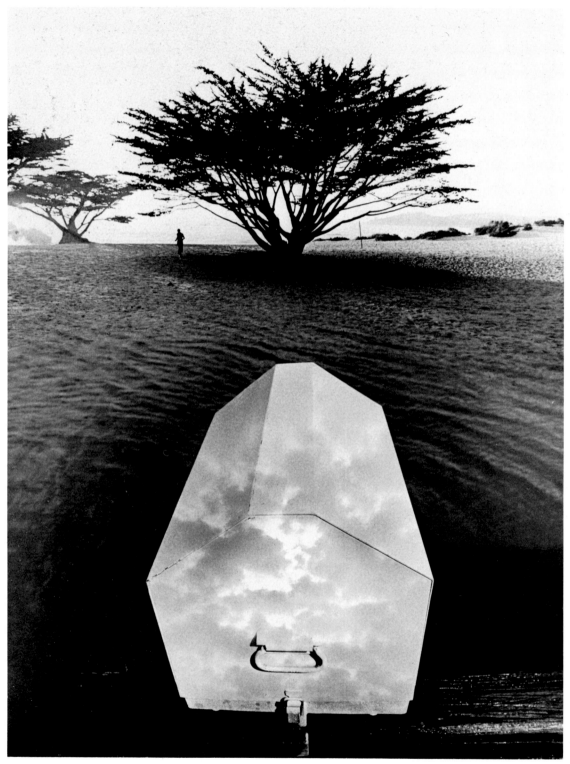

1974

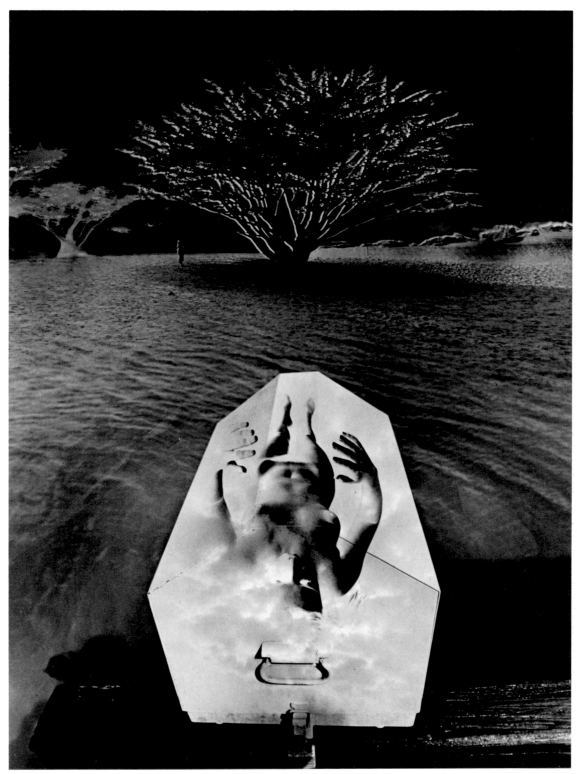

1974

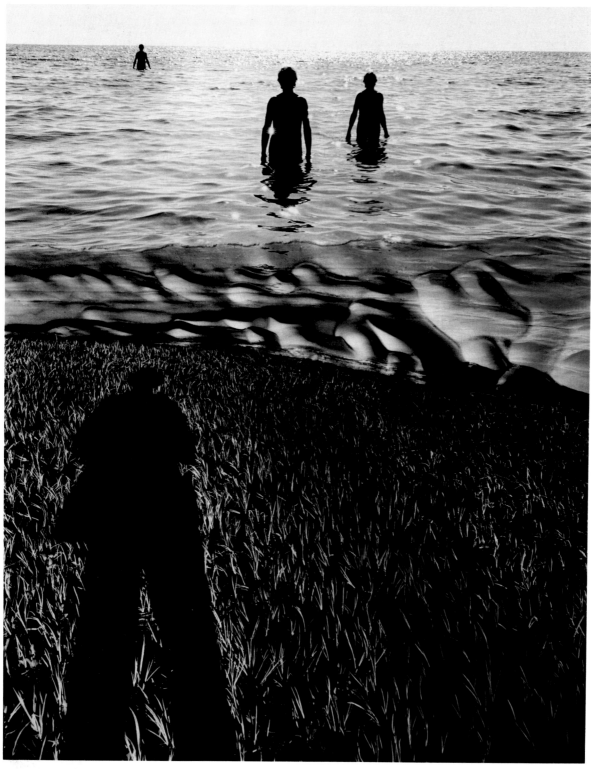

1971

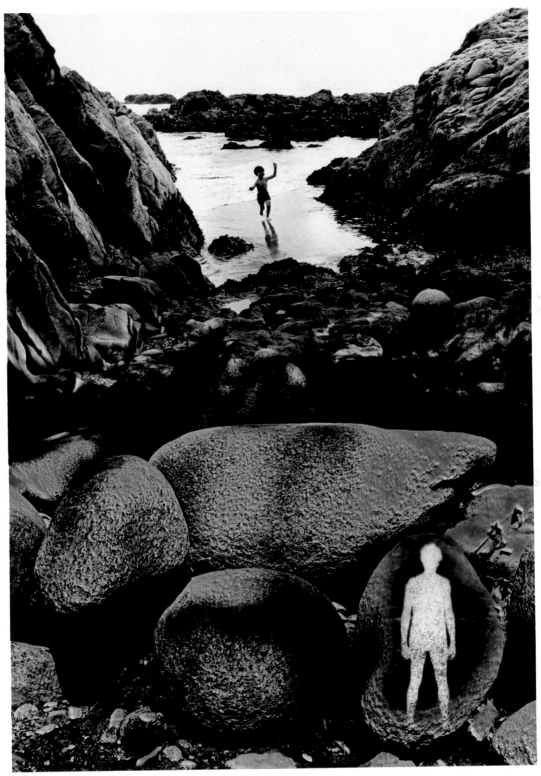

1972

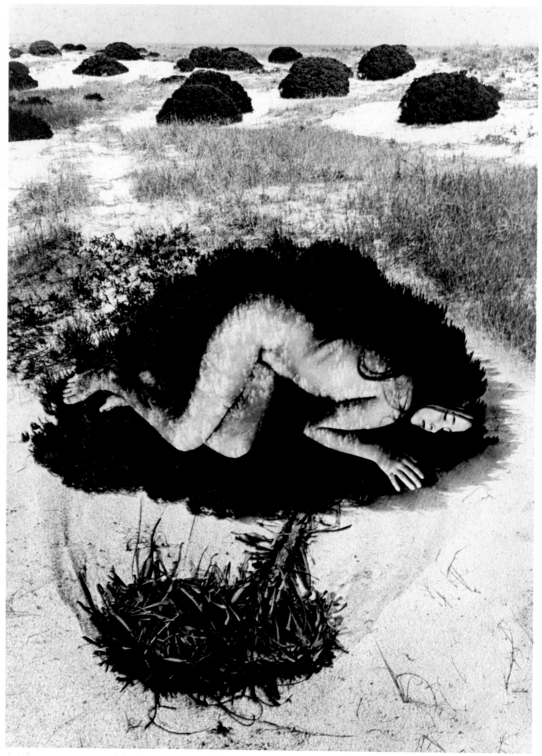

1972

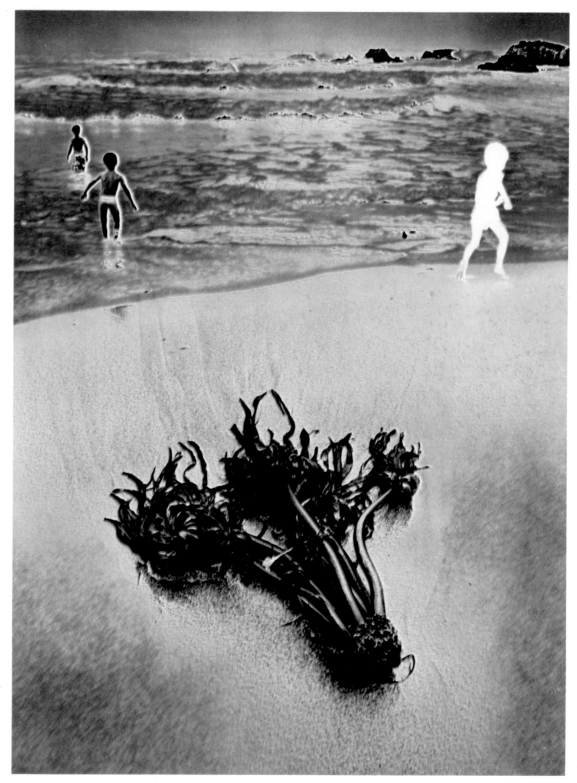

1972

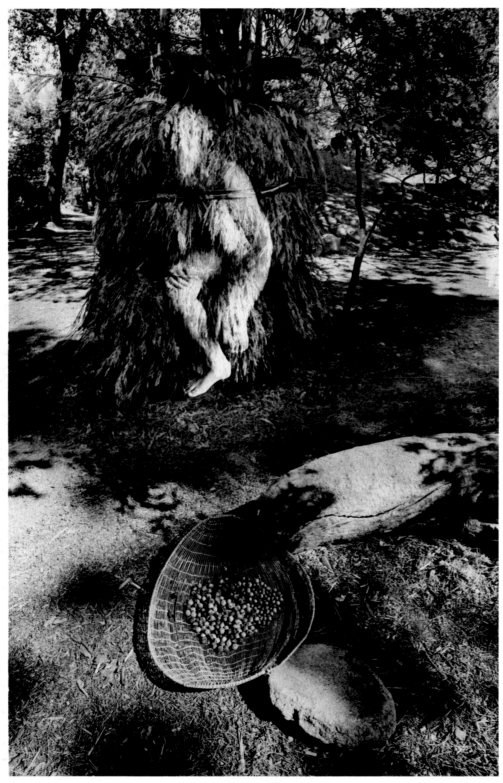

1974

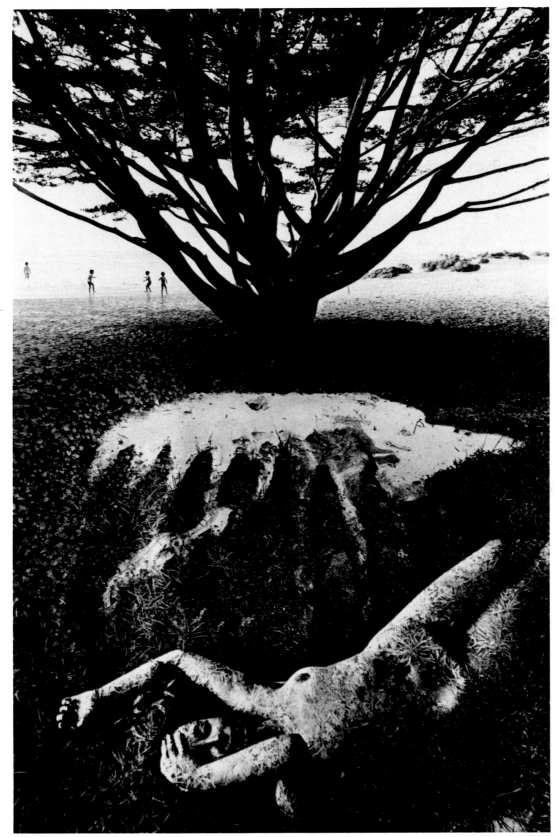

1974

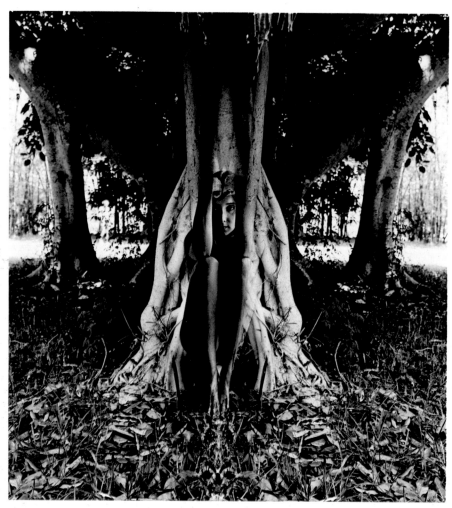

1972

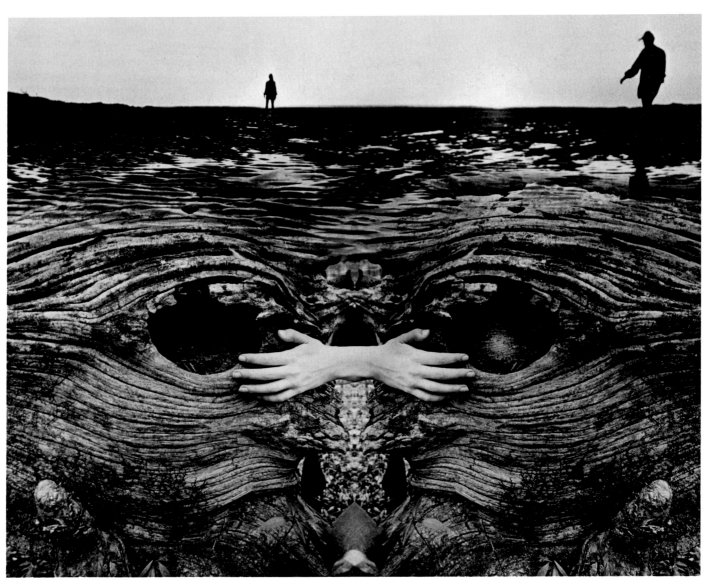

1974

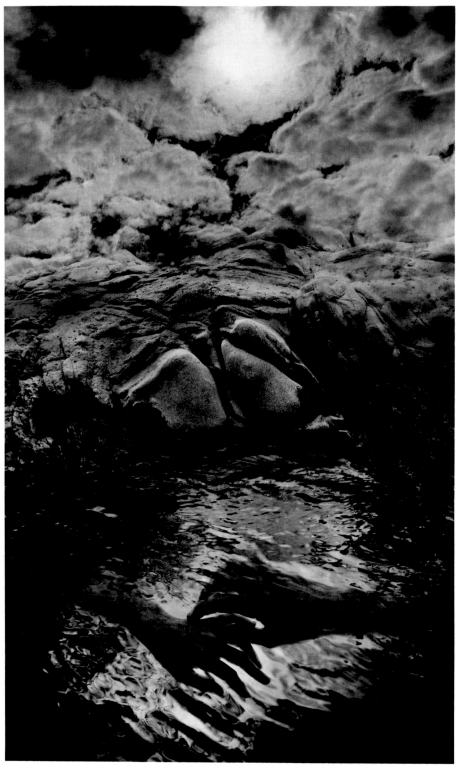

1972

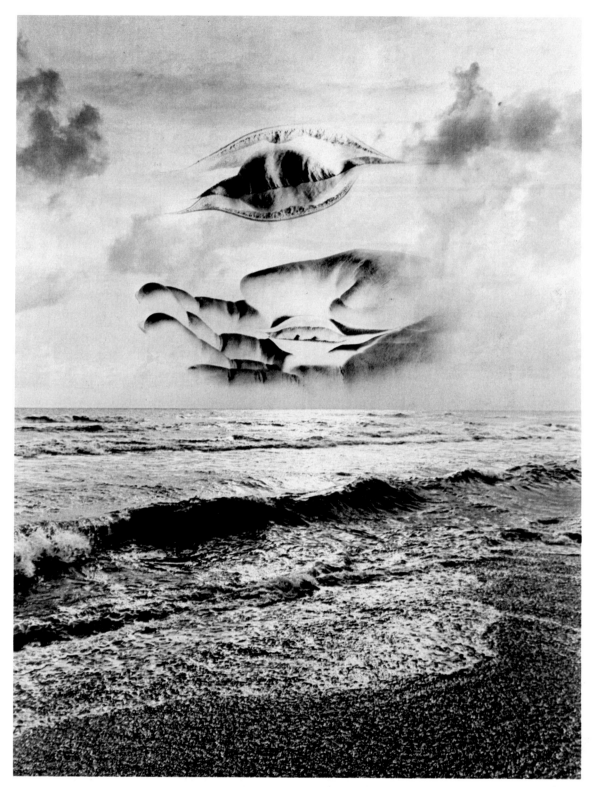

1970

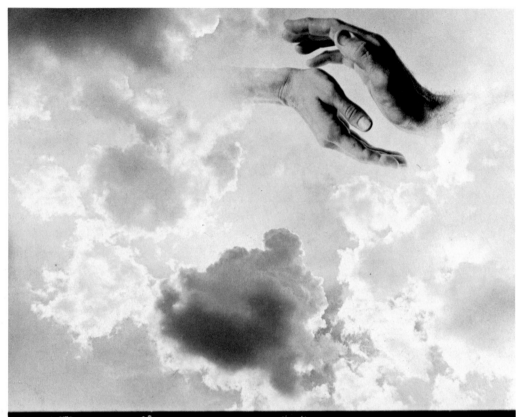
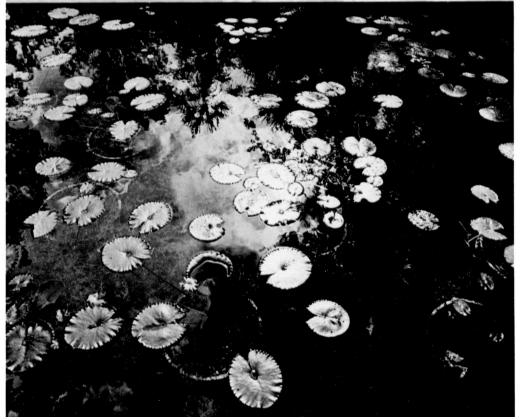

1974

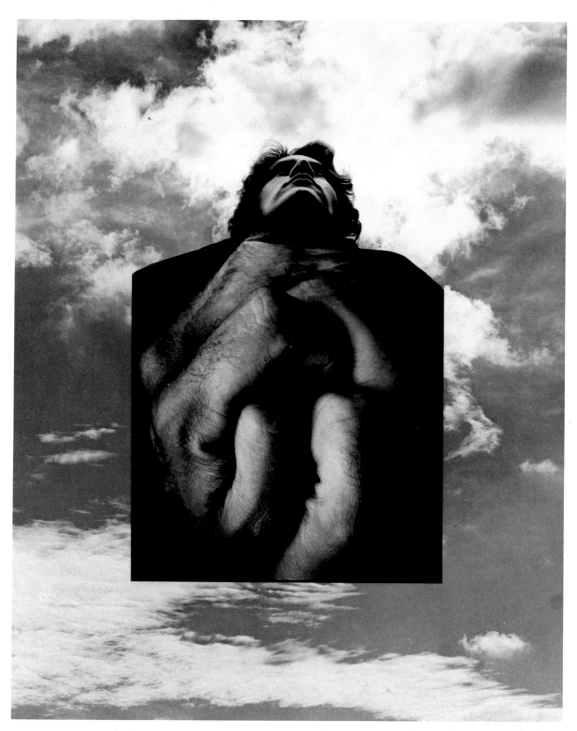

Marilynn in the Sky 1967

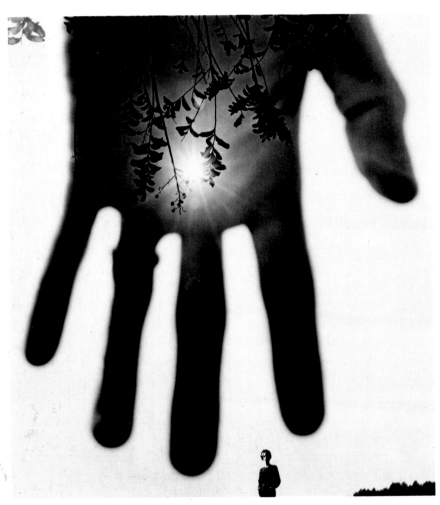

The Feel of Light 1966

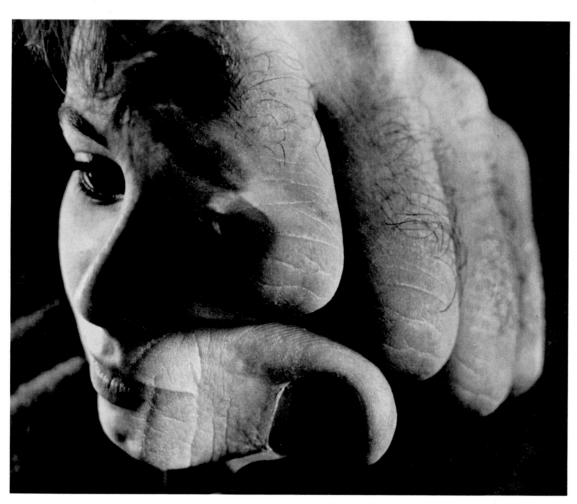

Symbolic Mutation 1961

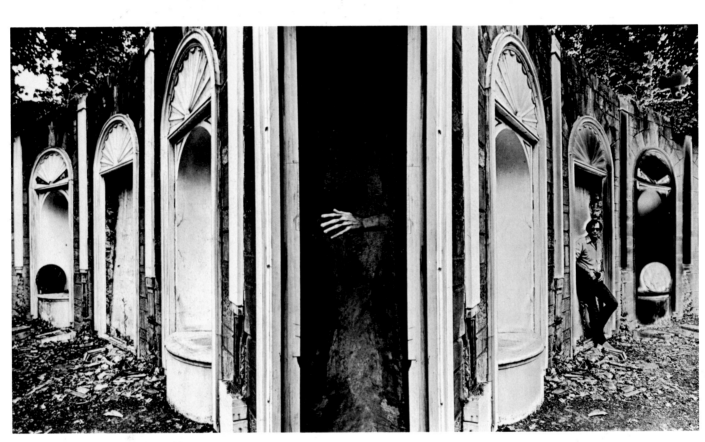

1973

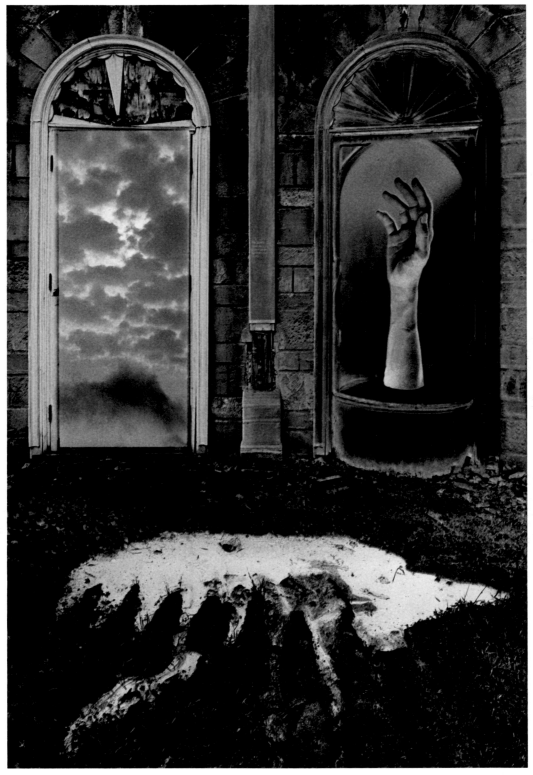

1974

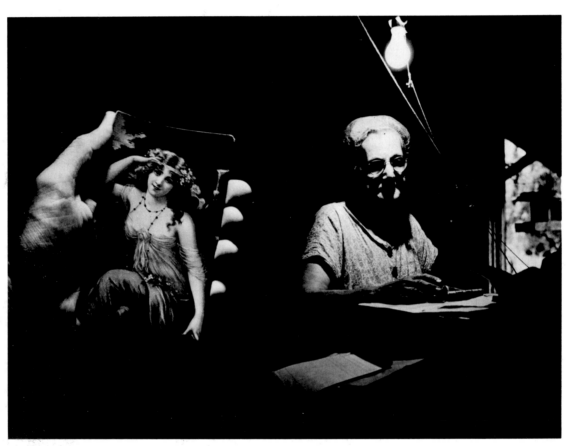

1963

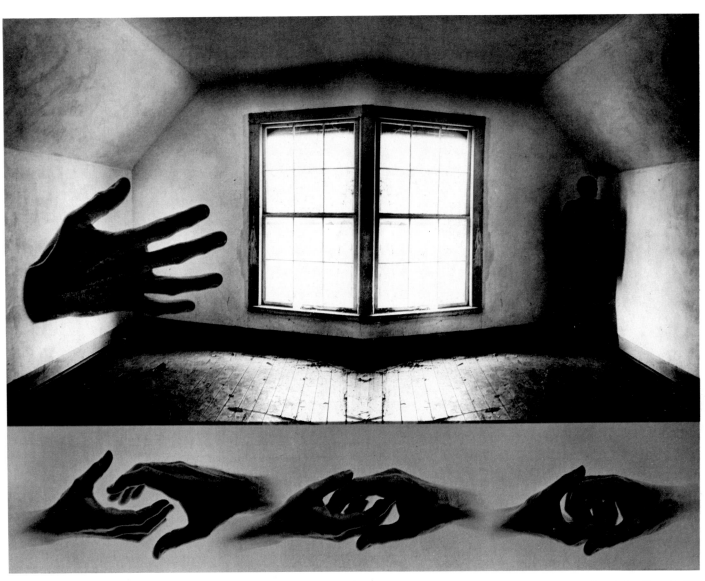

Questioning Moment 1971

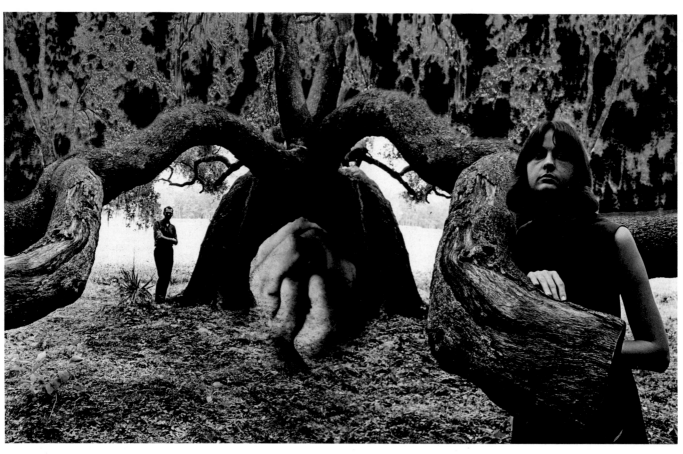

1968

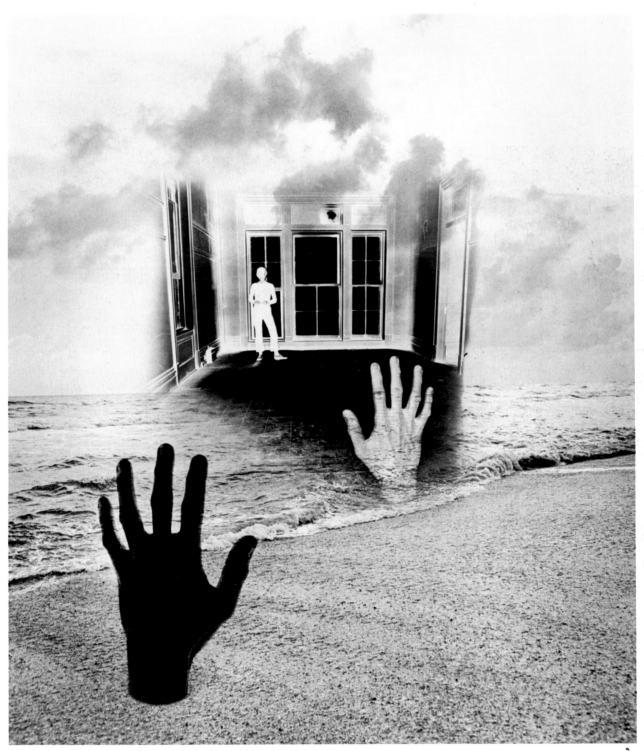

Navigation without Numbers 1971

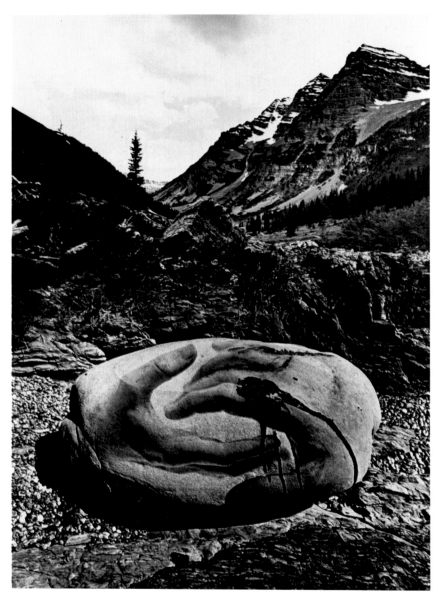

1970

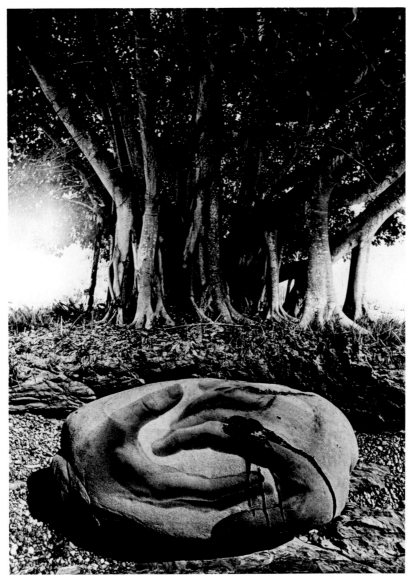

1970

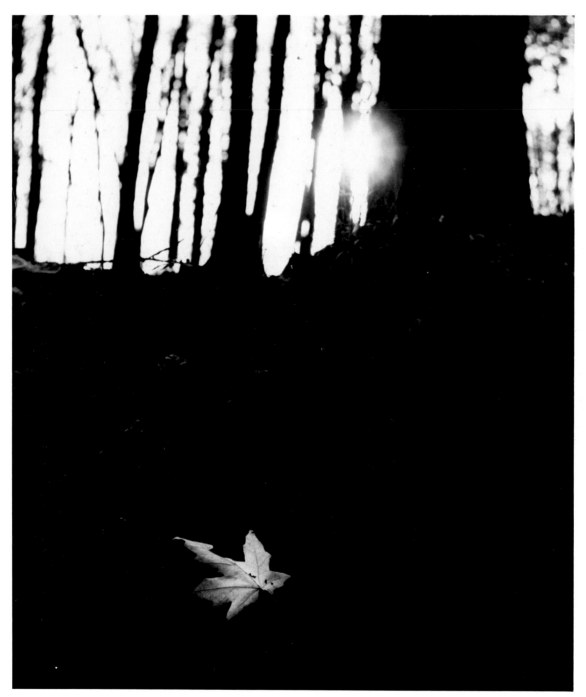

1959

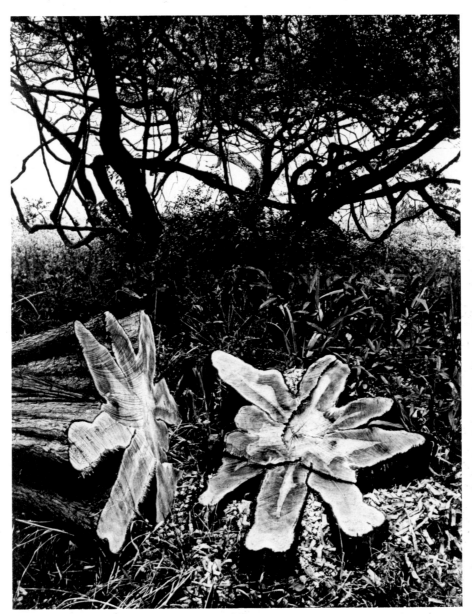

1964

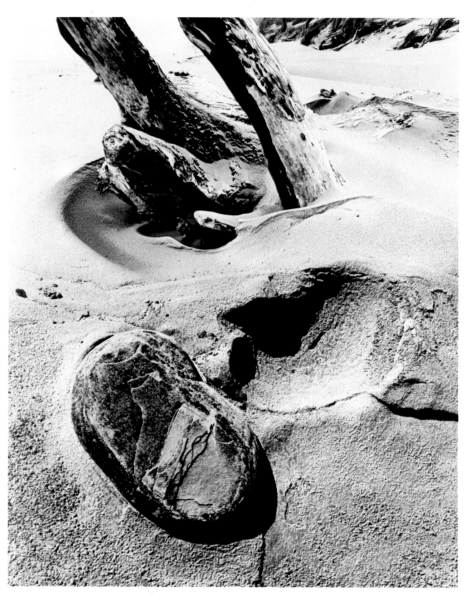

1973

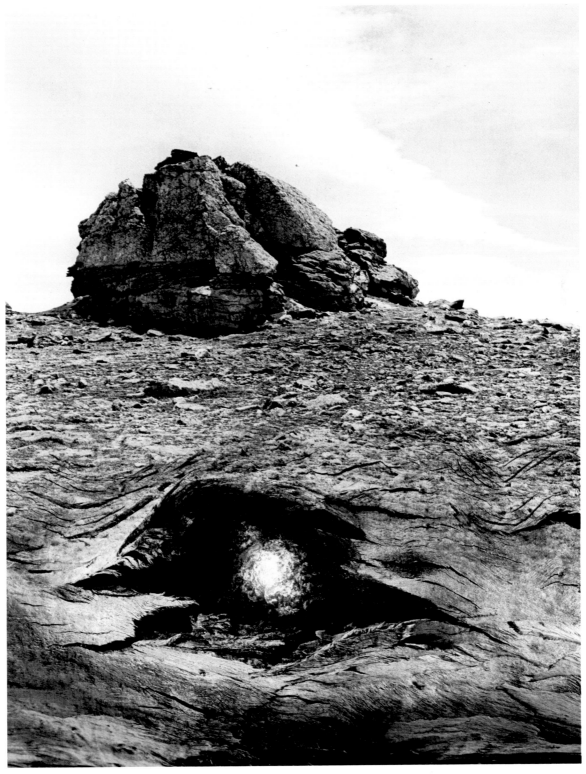

1972

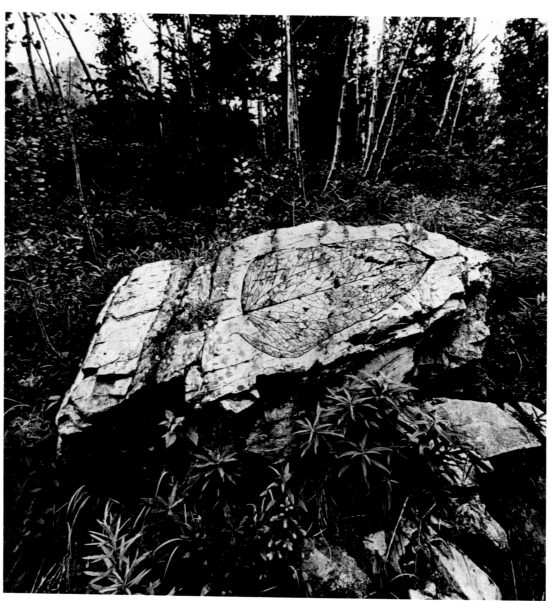

1970

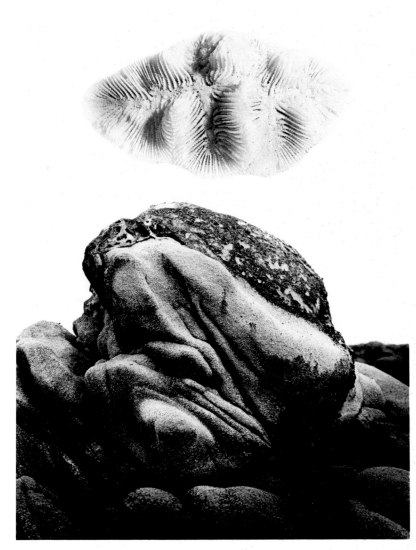

1970

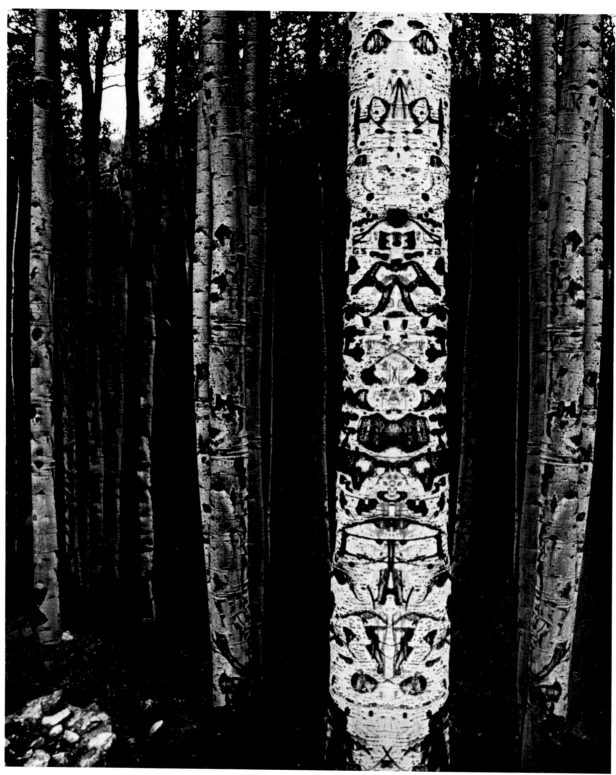

Totemic Aspen 1970

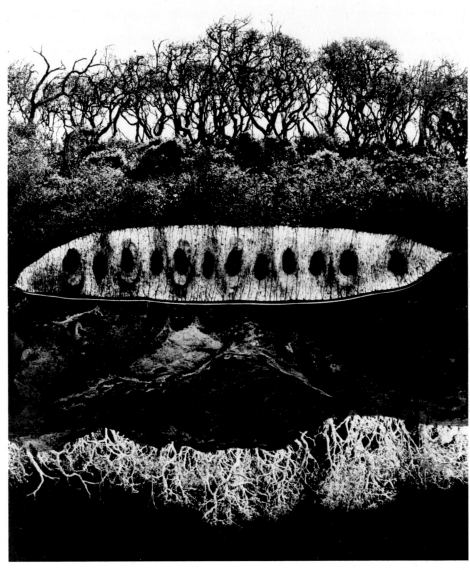

April Is the Cruelest Month 1967

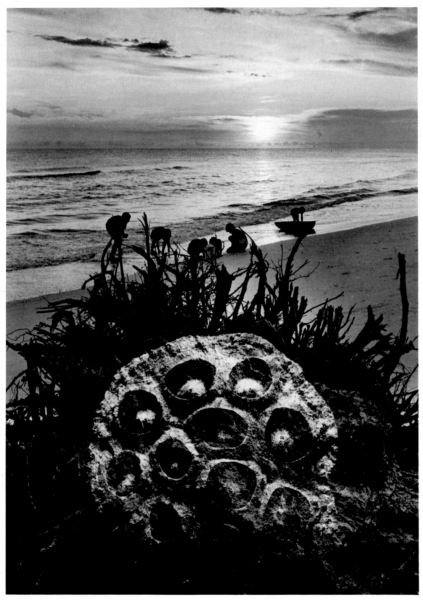

1968

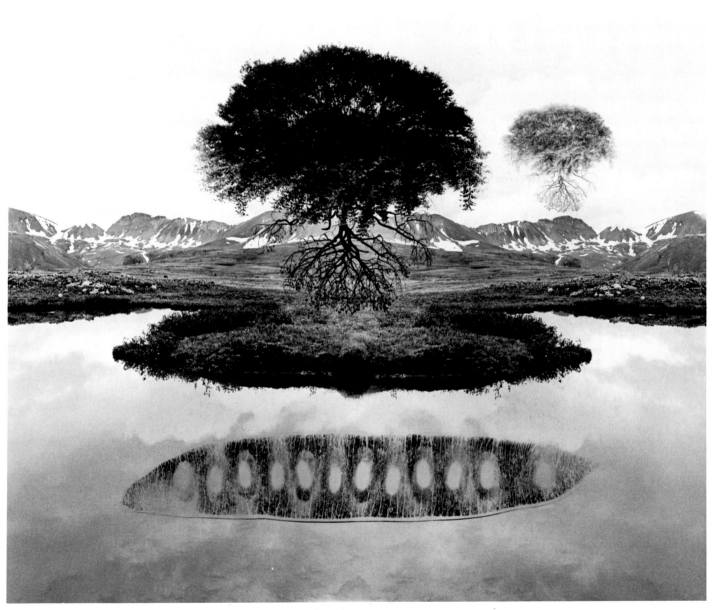

1969

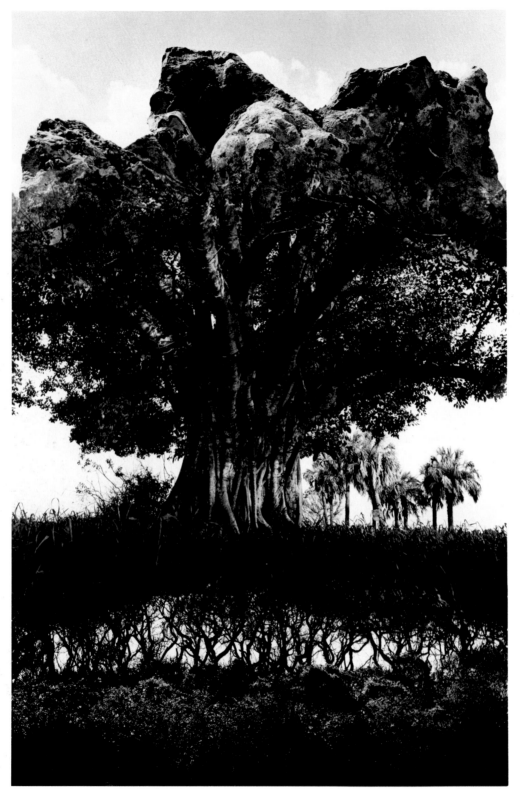

Rock-Tree 1969

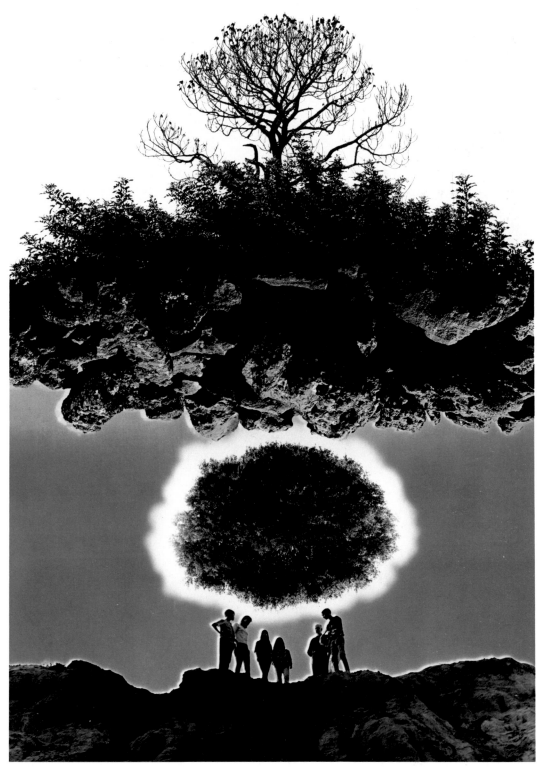

1967

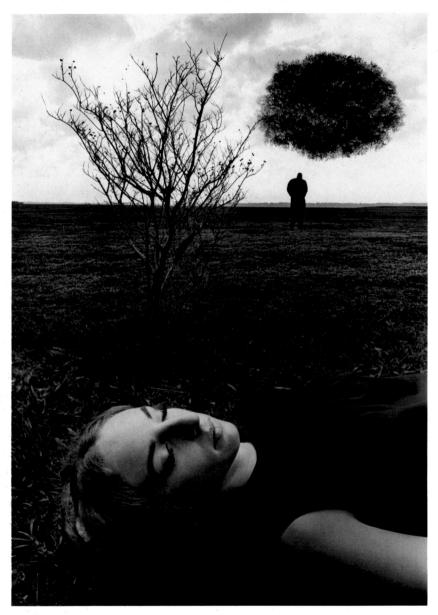

1966

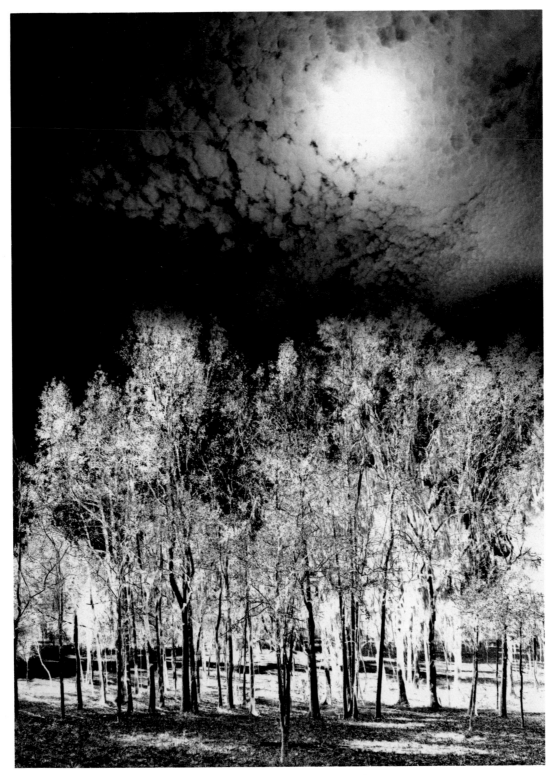

1964

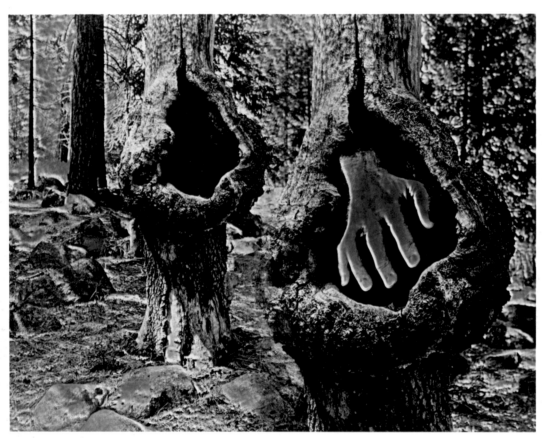

1973

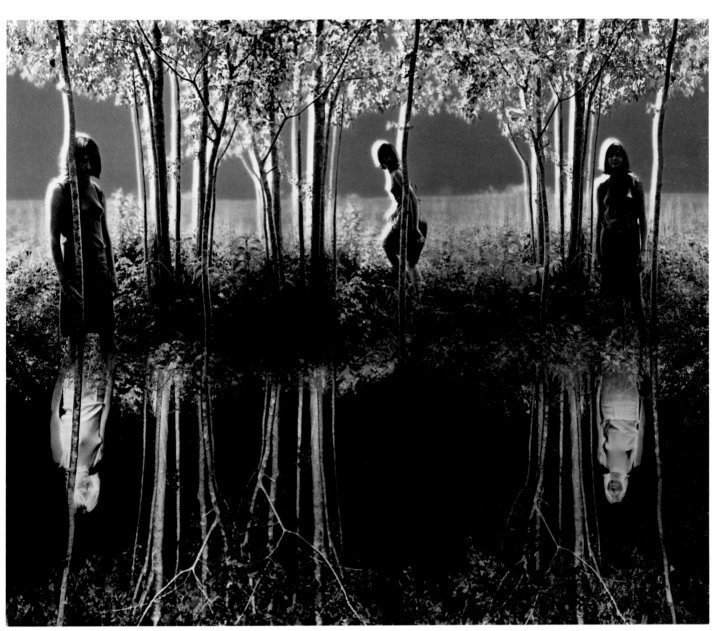

Small Woods Where I Met Myself (final version) 1967

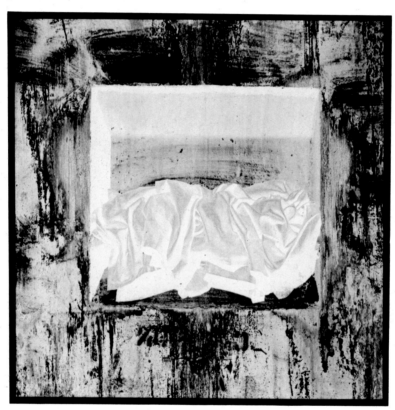

1968

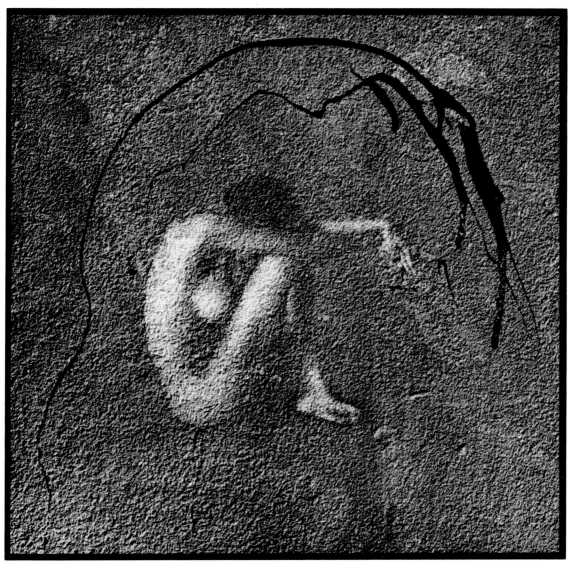

1968

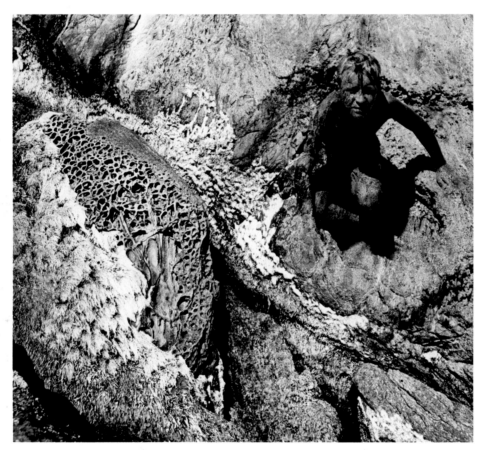

1970

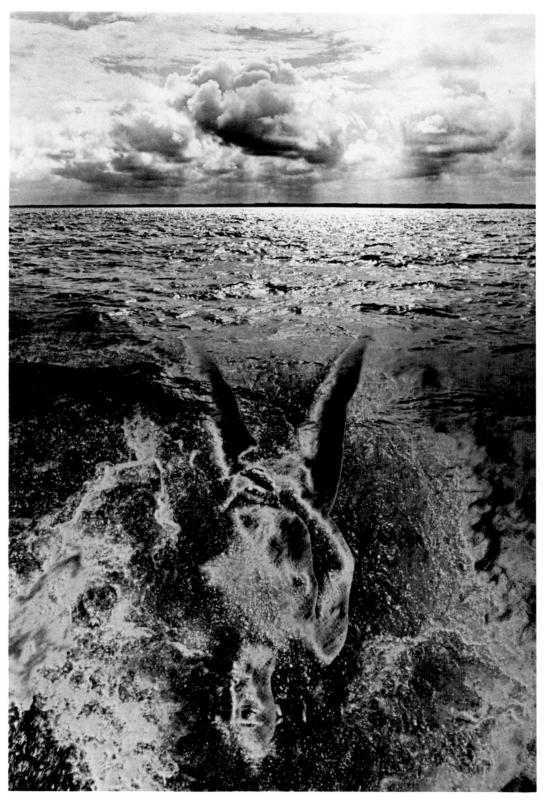

1972

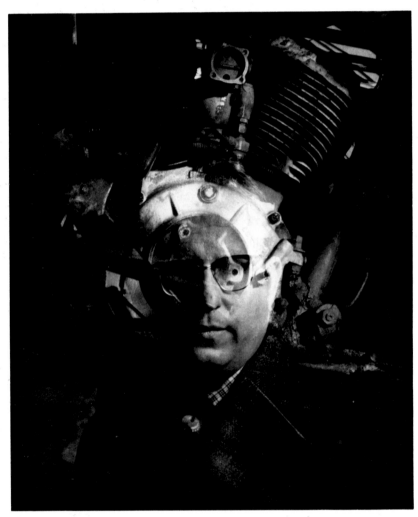

Mechanical Man #1 1959

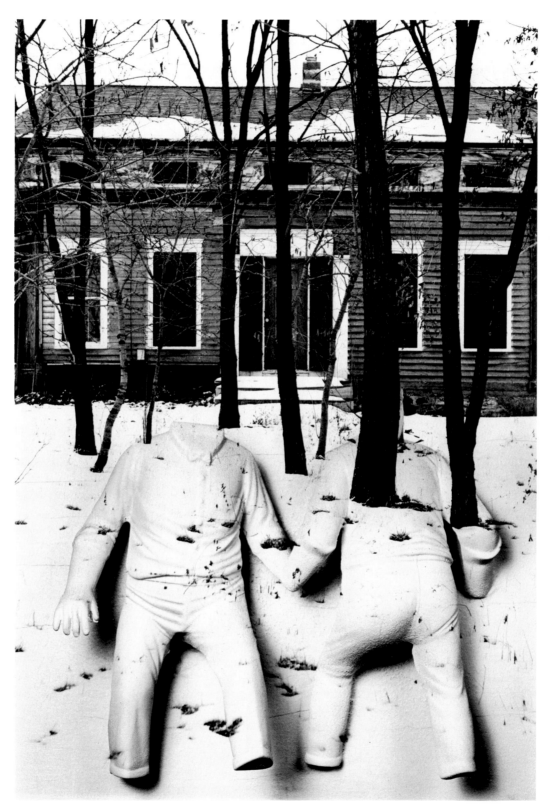

1968

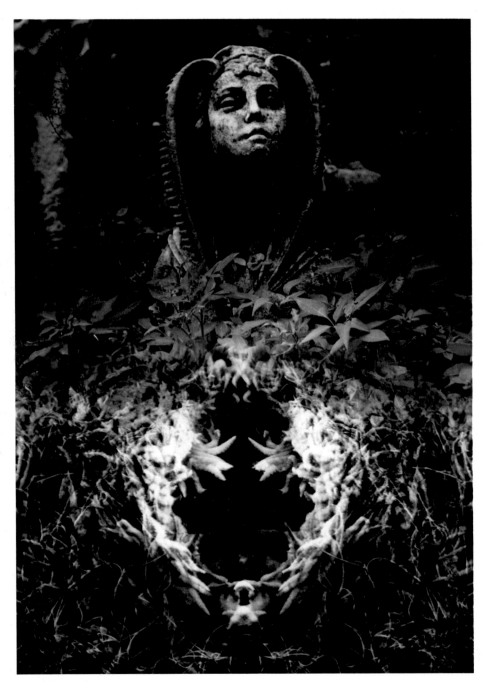

1965

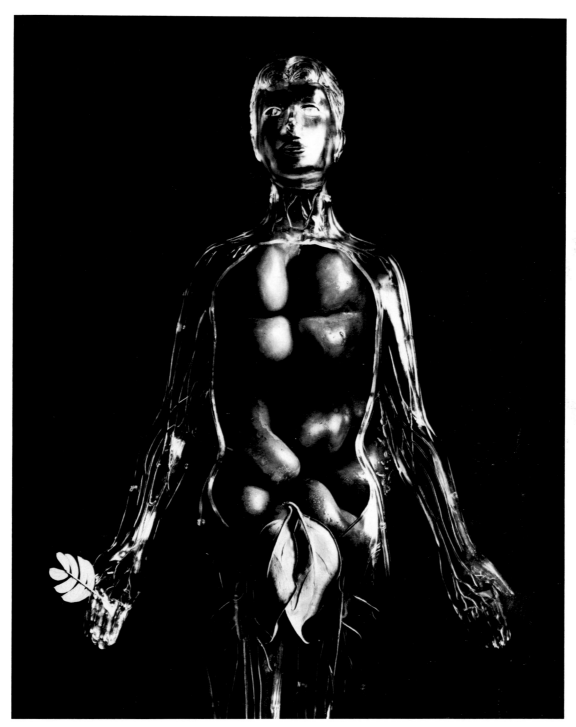

Hero 1961

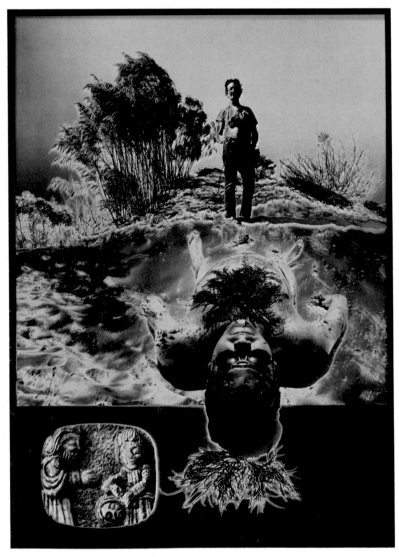

The Photographer as Assassin 1970

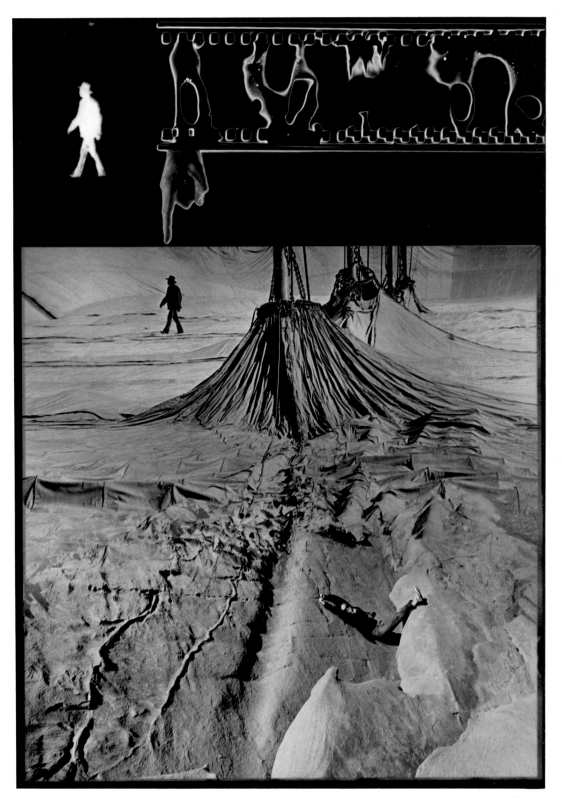

Simultaneous Implications 1973

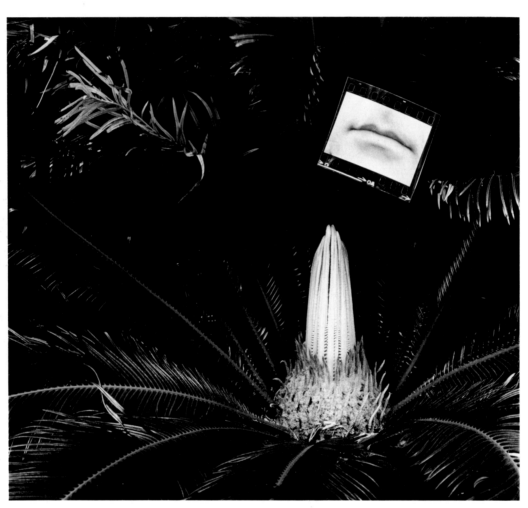

1974

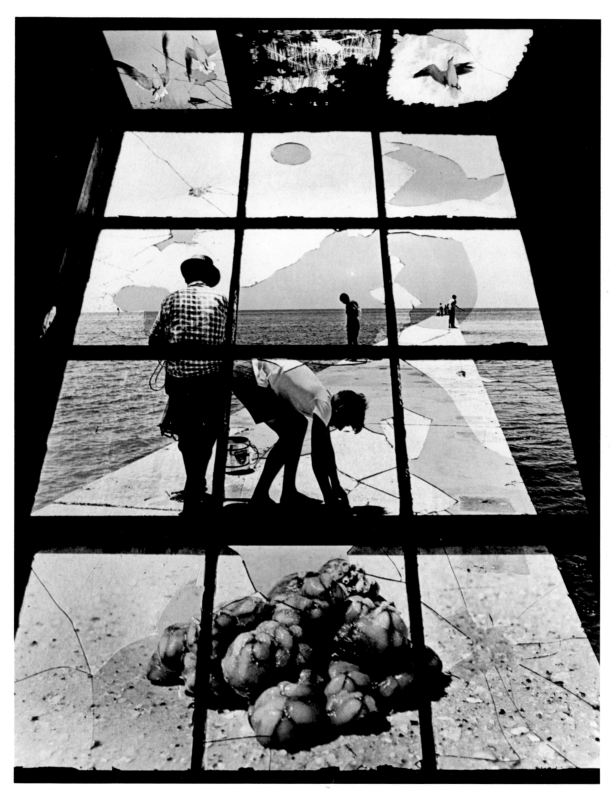

1970

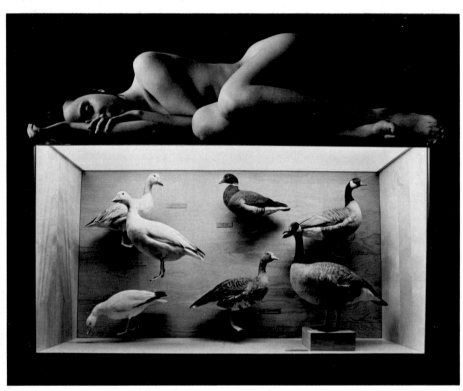

1973

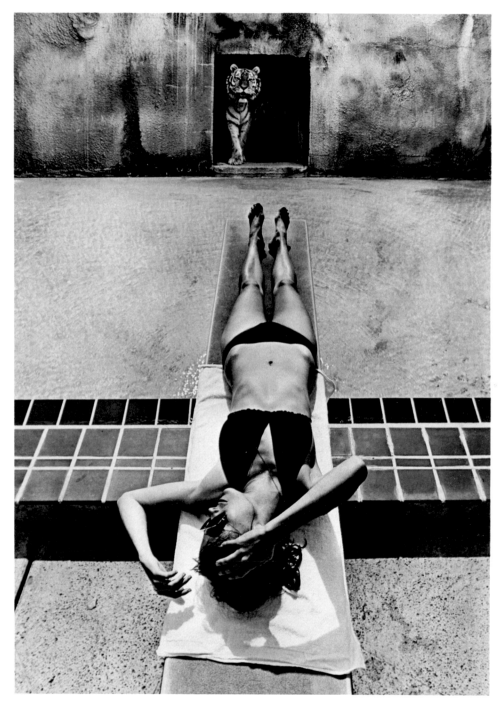

1974

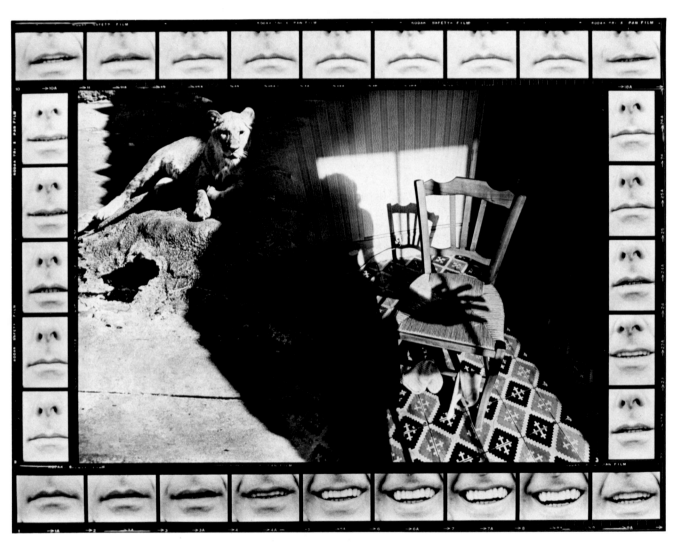

1974

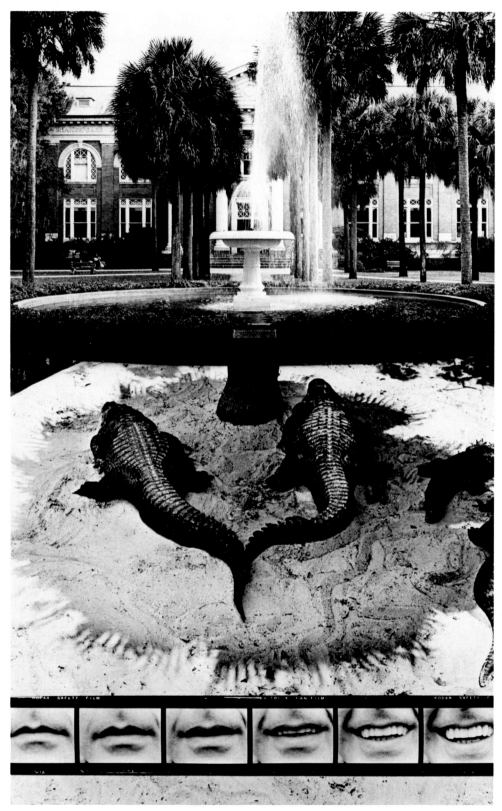

Welcome to Higher Education 1974

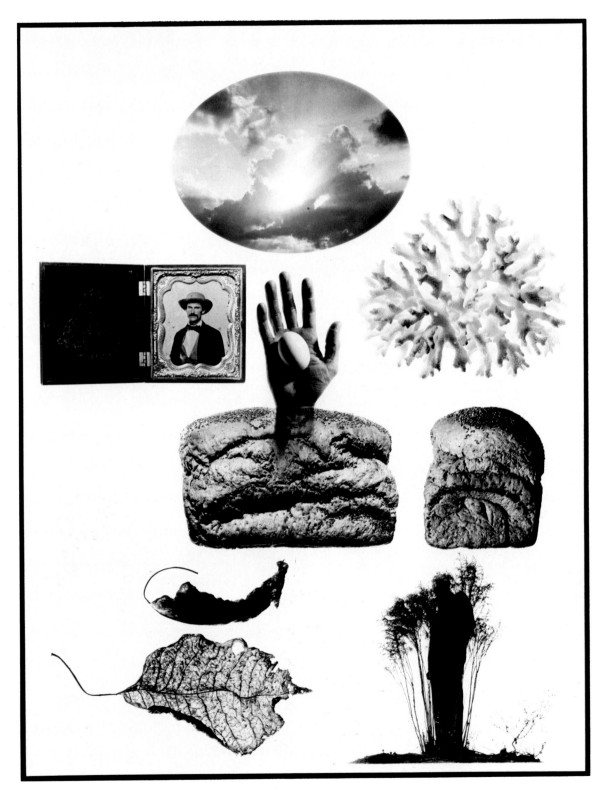

1971

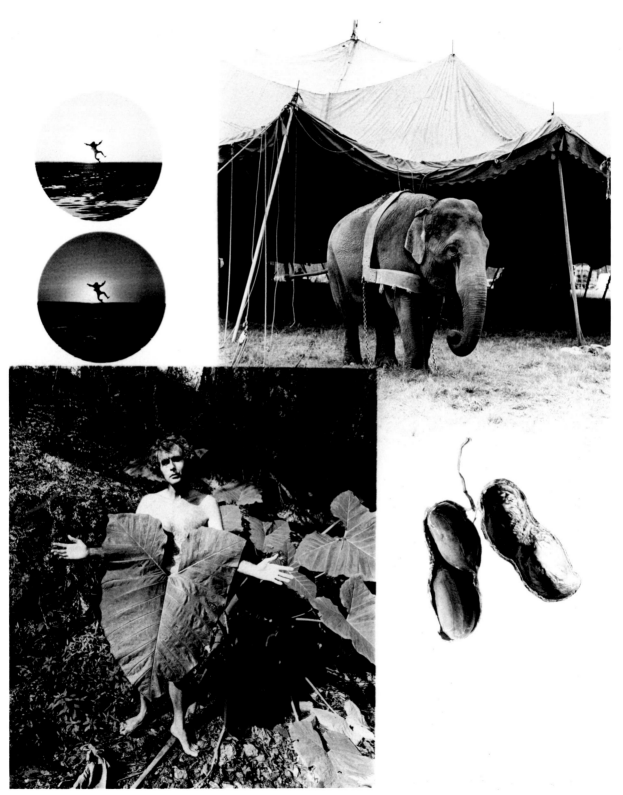

Elephant Ears & Other Friendly Spirits 1974

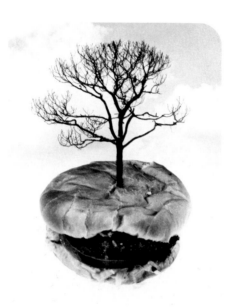

Little Hamburger Tree 1970

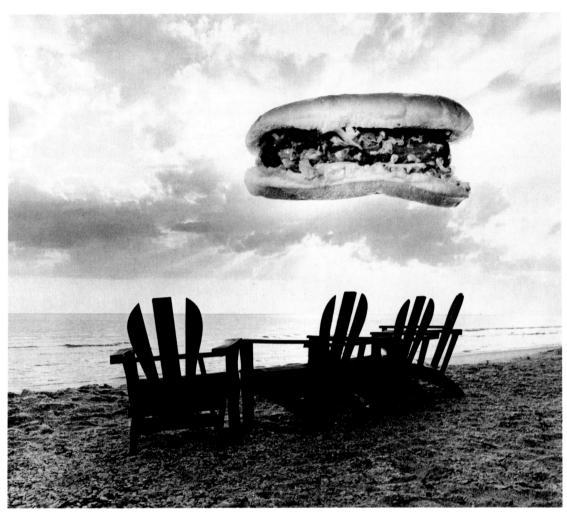

1971

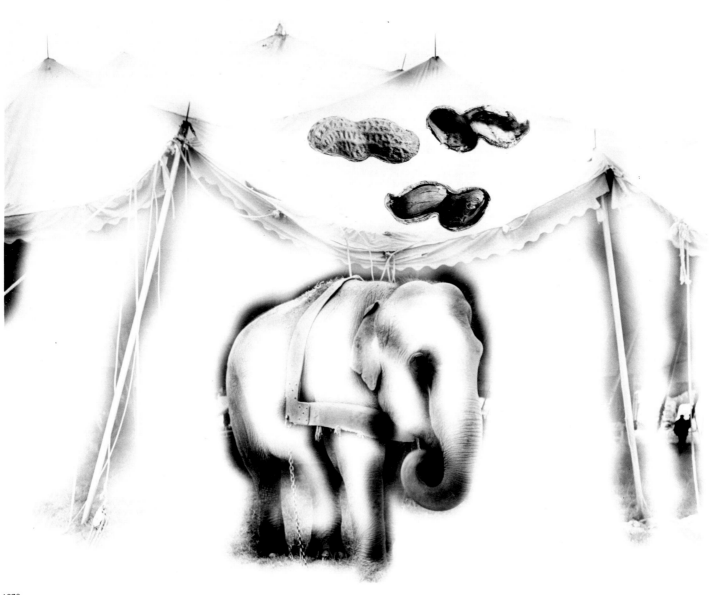

1973

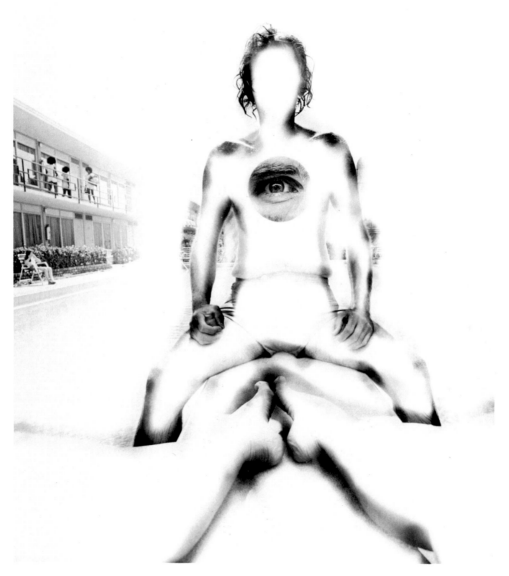

1974

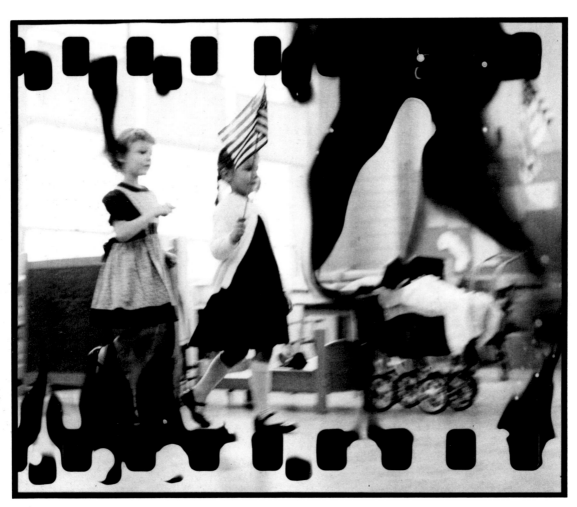

1967

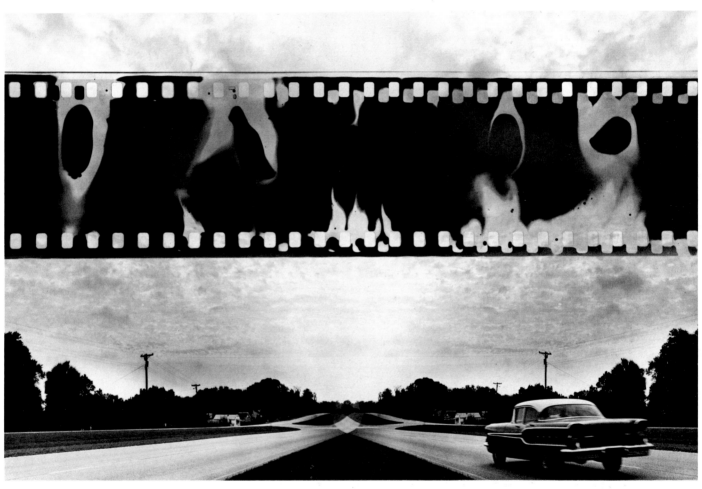

God's Home Movies 1967

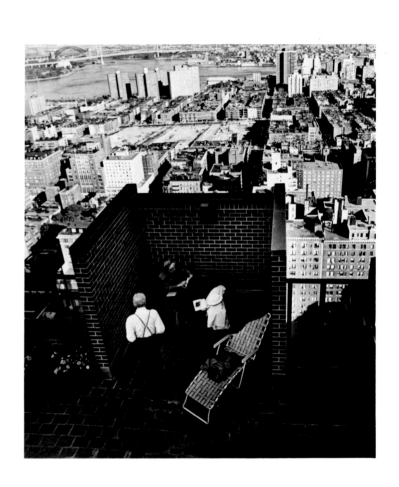

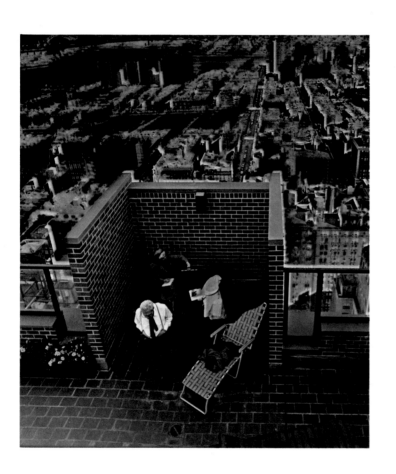 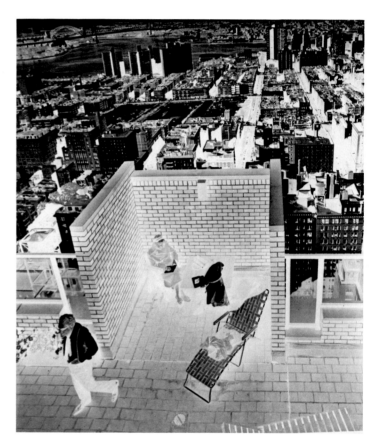

Reminiscing about the Future 1972

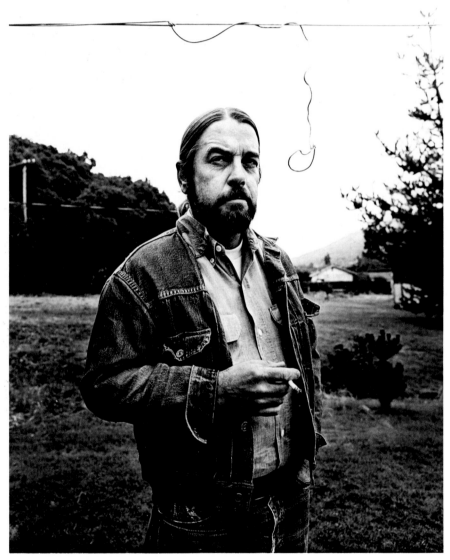

Bob Heinecken 1973

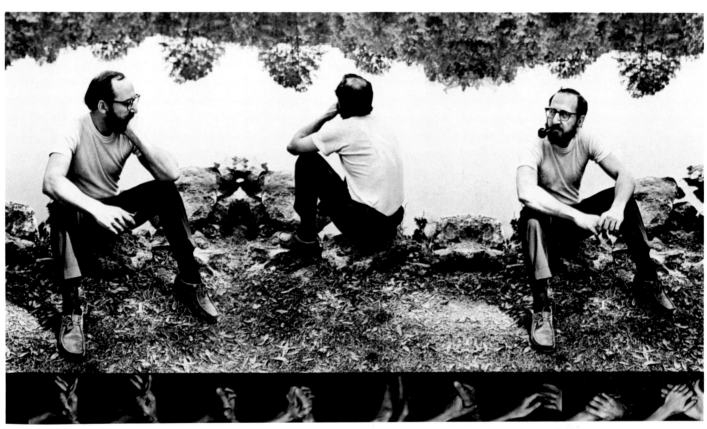

Dr. Carl Chiarenza 1970

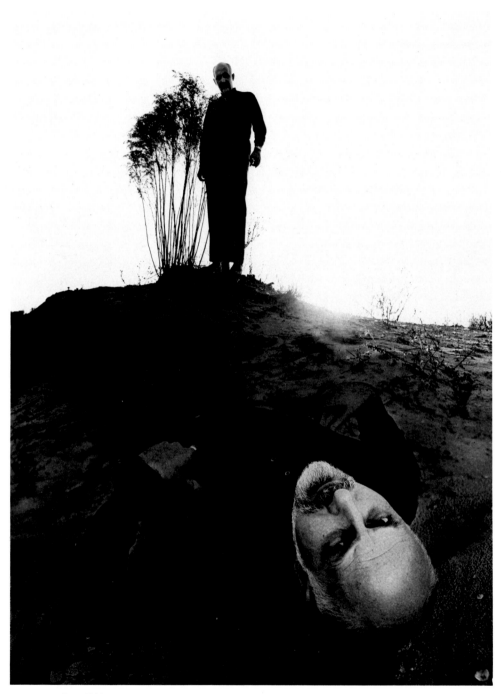

Ralph Hattersley 1966

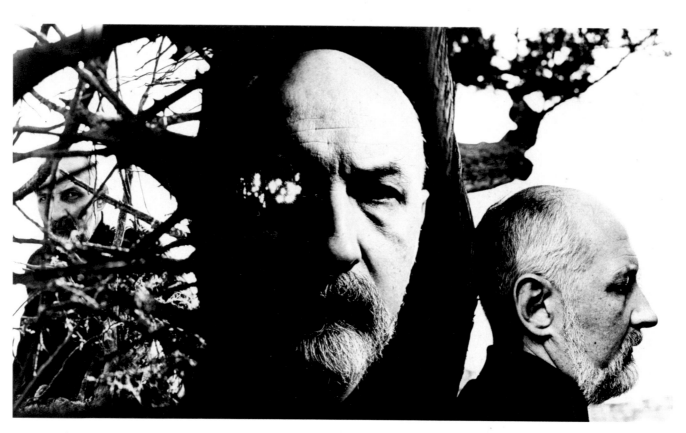

Ralph Hattersley 1966

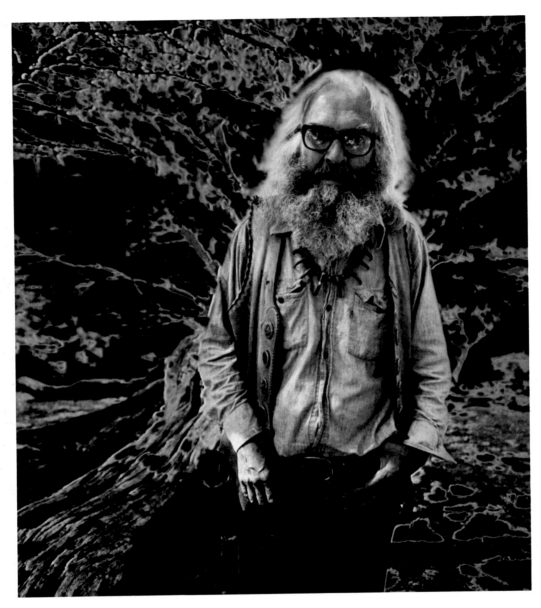

Bill Everson 1972

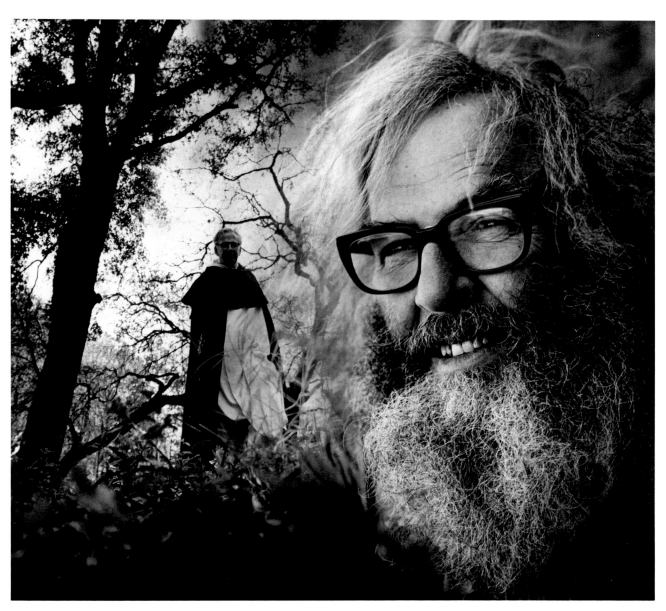

Brother Antoninus/Bill Everson 1968/1972

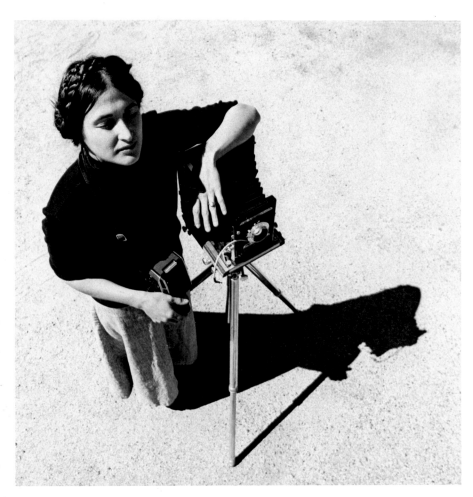

Judy Dater 1973

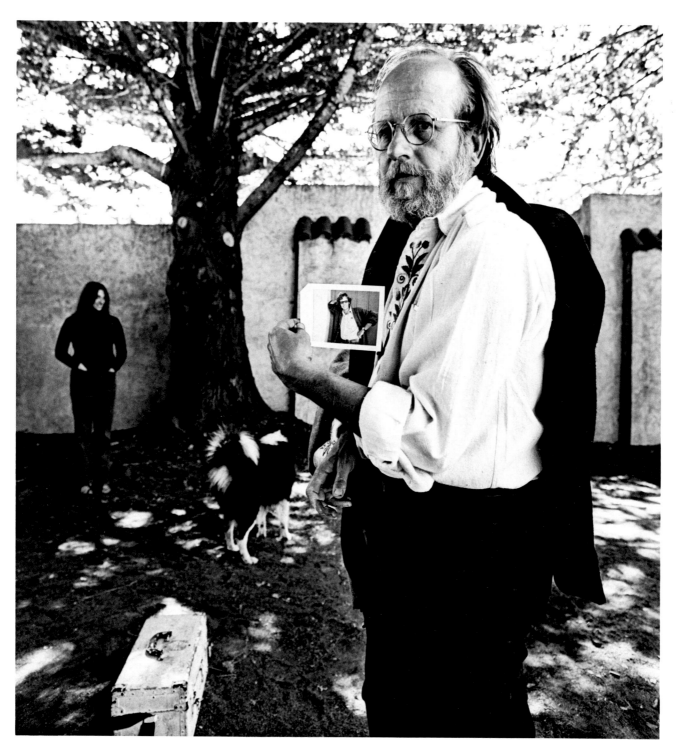

Jack Welpott 1972

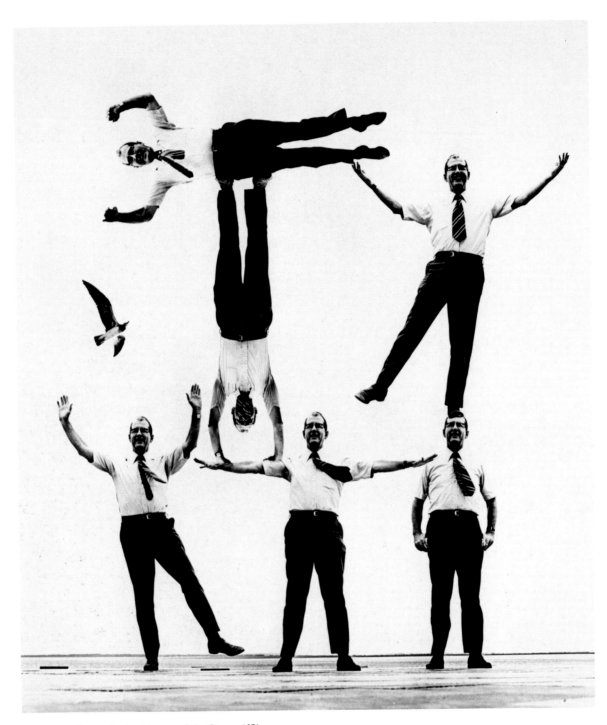

John Hurdle, Curator Ringling Museum of the Circus 1971

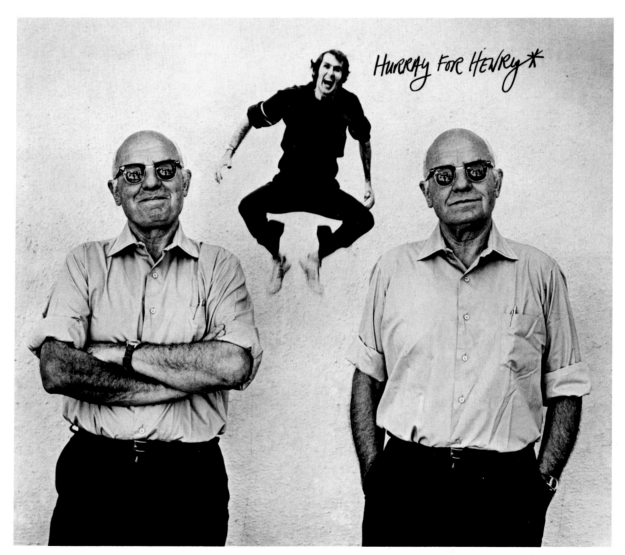

Hurray for Henry*

Henry Holmes Smith 1972

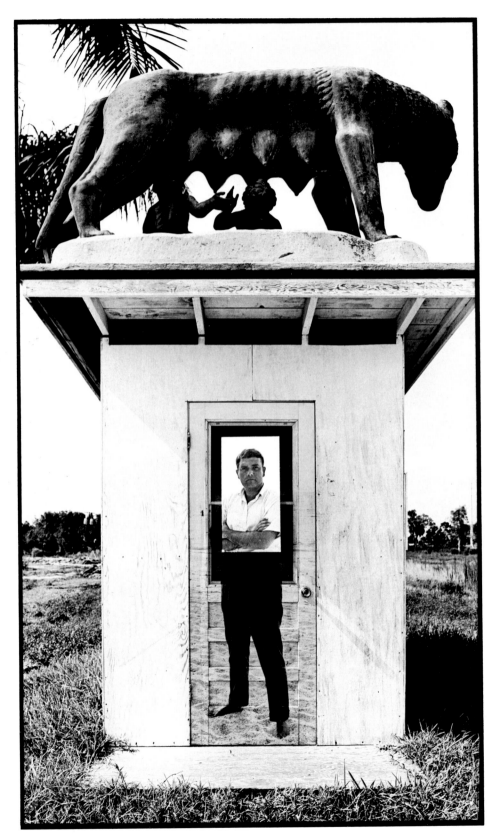

Romulus, Remus, and Peter 1968

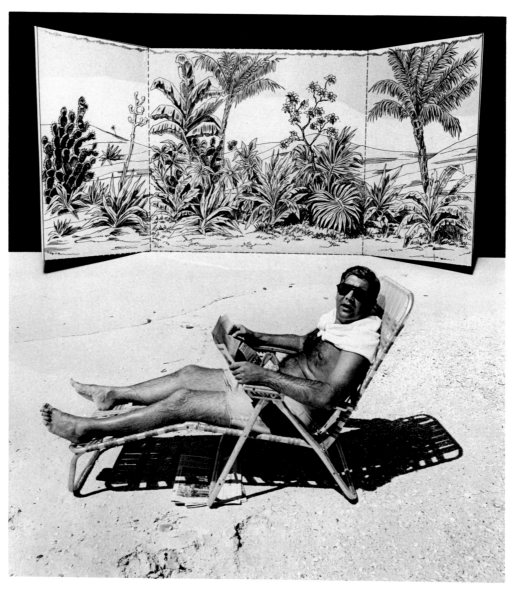

Peter Bunnell 1972

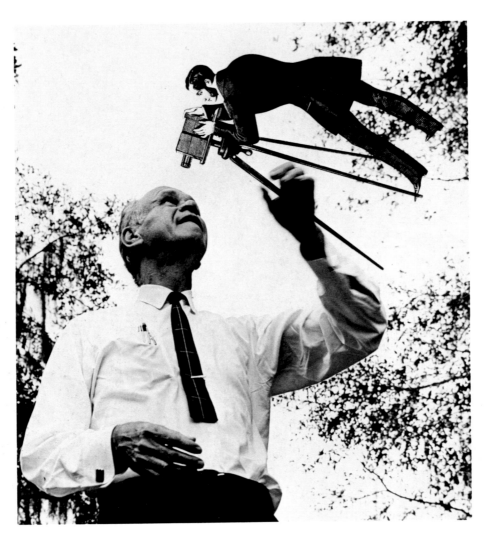

Beaumont Newhall 1968

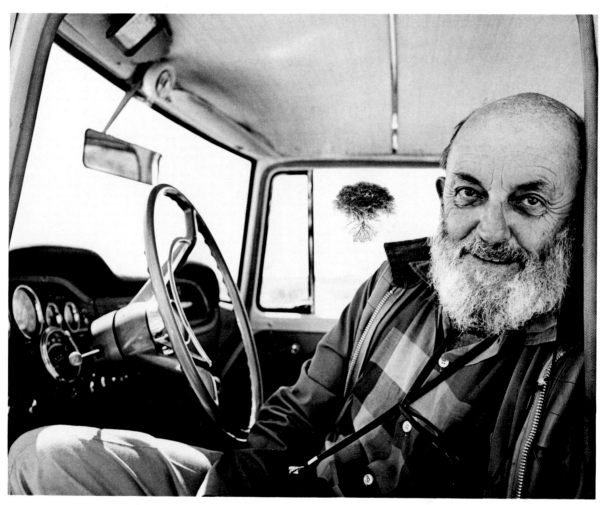

Ansel Adams 1970

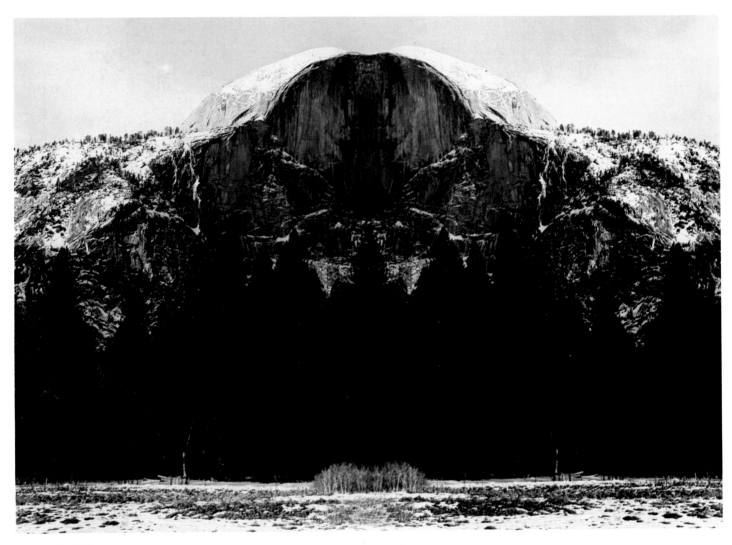

"Full-Dome" 1973

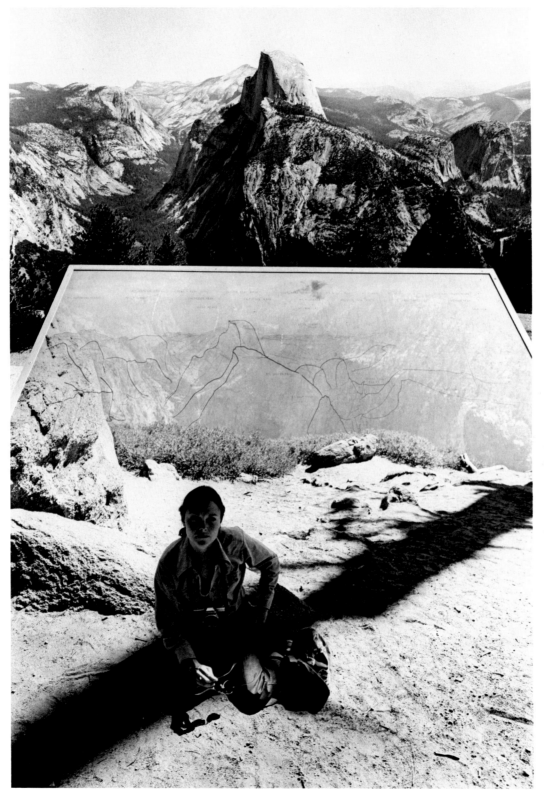

Diane/Yosemite 1974

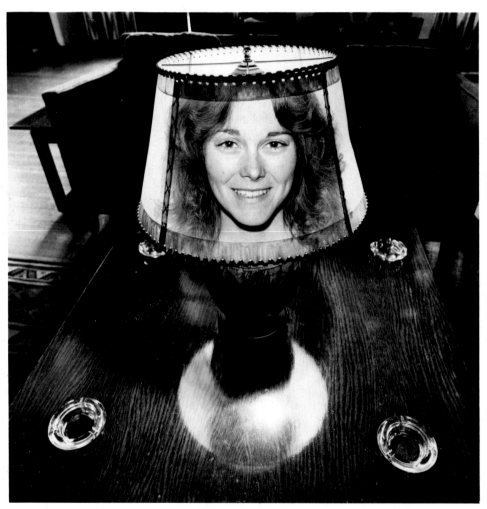

Diane Farris 1974

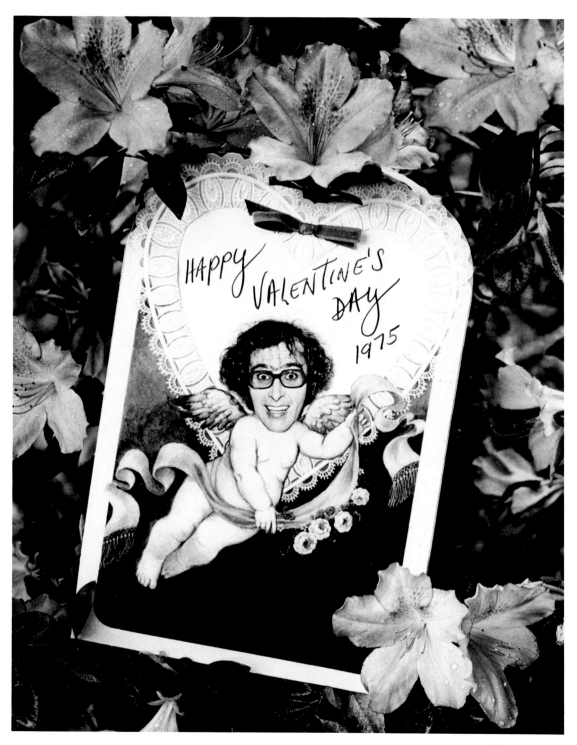

Self-portrait 1975

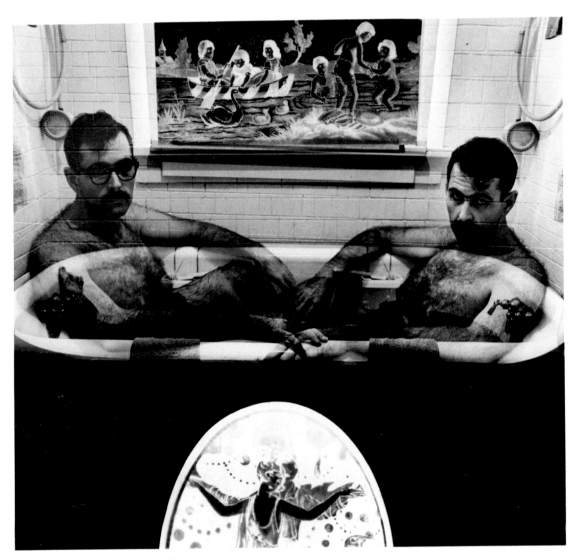

Self-portrait as Robinson & Rejlander 1964

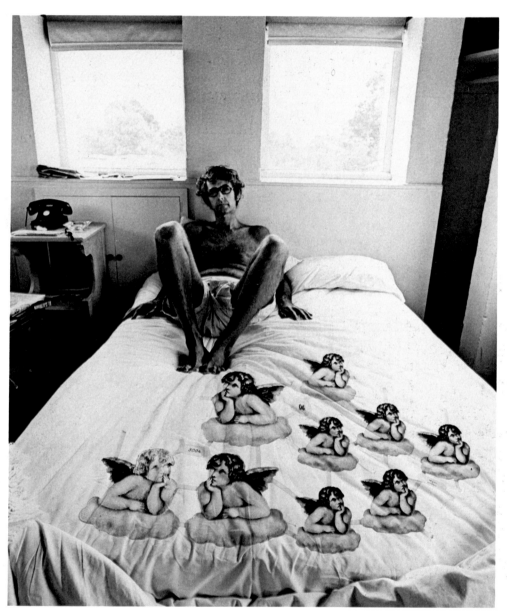

Self-portrait 1972

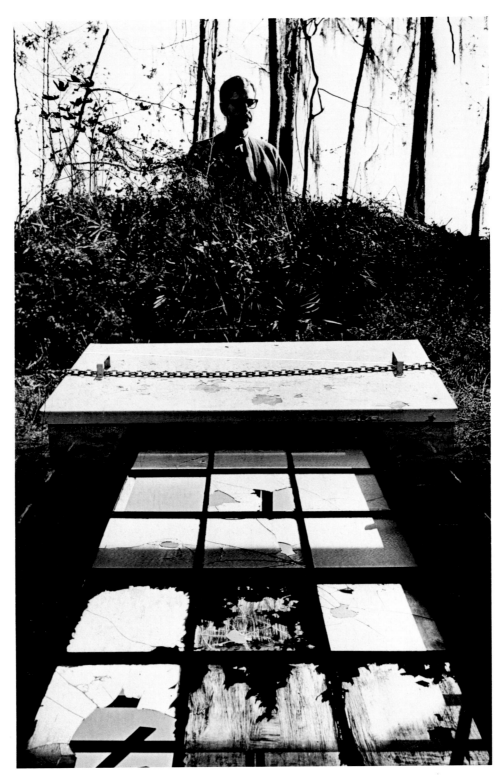

Self-portrait 1968

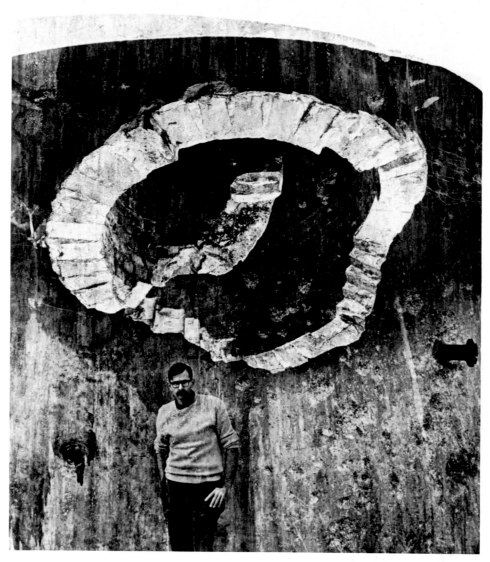

Self-portrait 1963

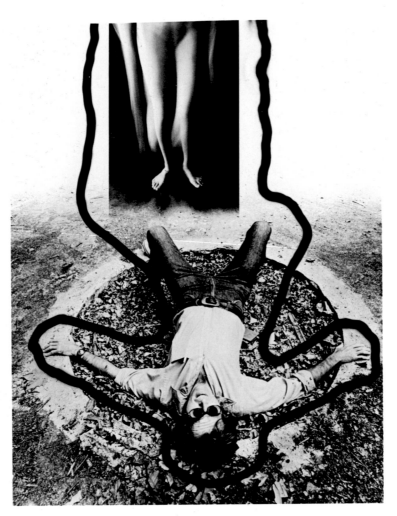

Self-portrait 1973

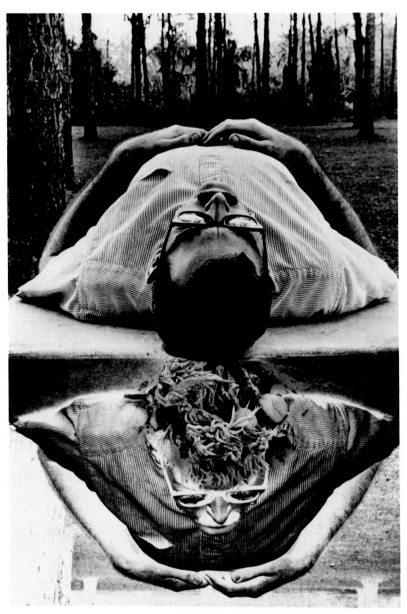

Self-portrait 1967

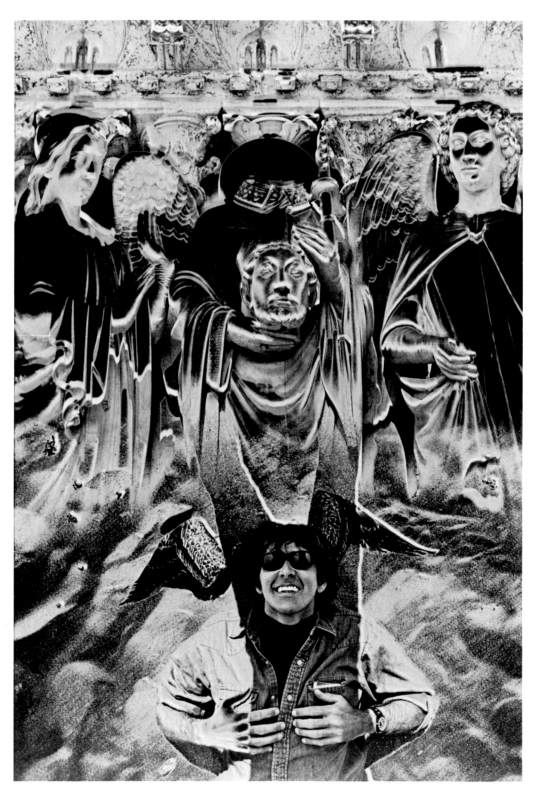

Notre Dame self-portrait 1973

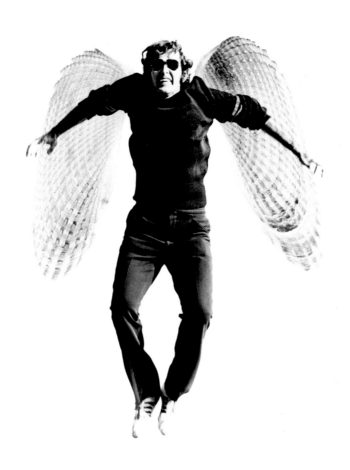

Self-portrait 1971

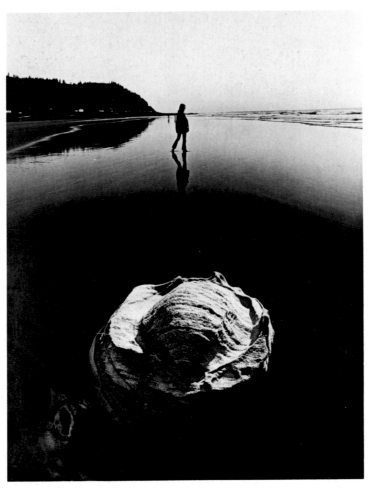

1973

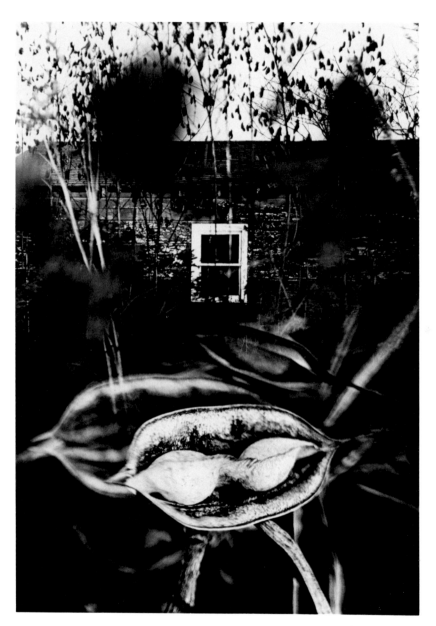

Beginnings 1962

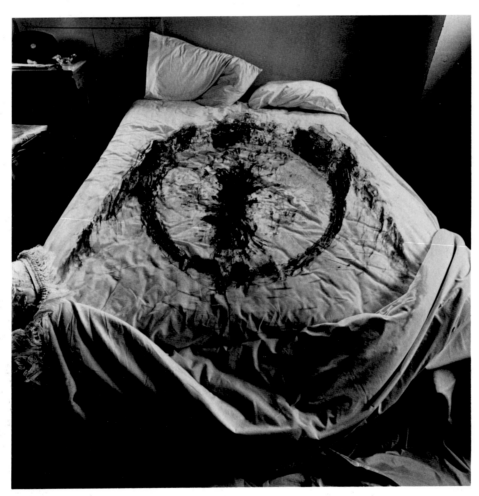

1972

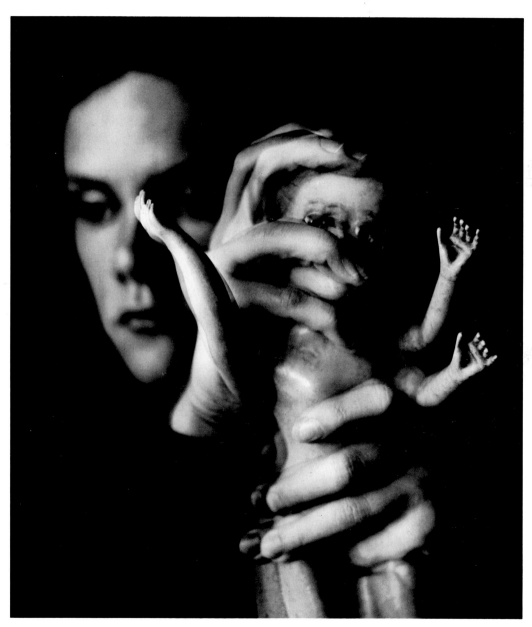

Riddle of Innocence #1 1961

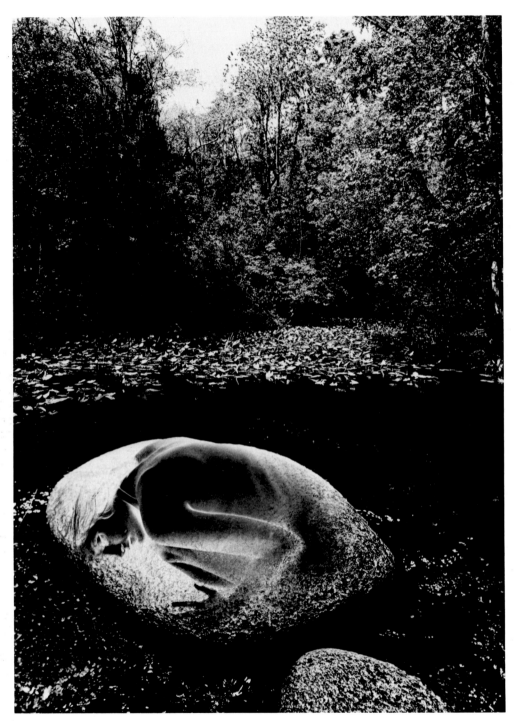

1972

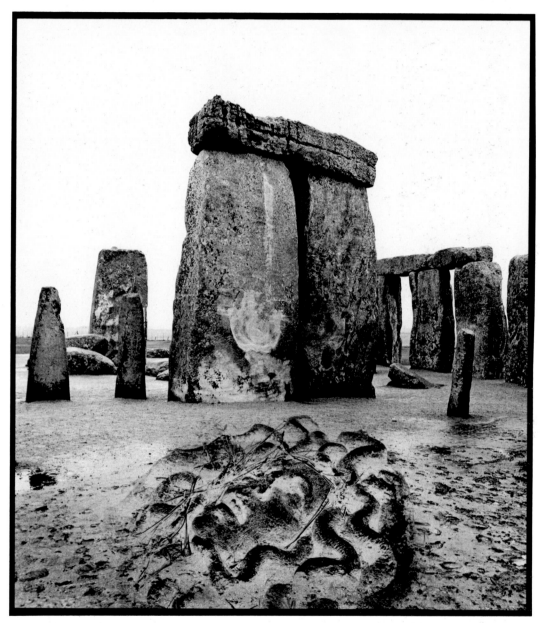

1971

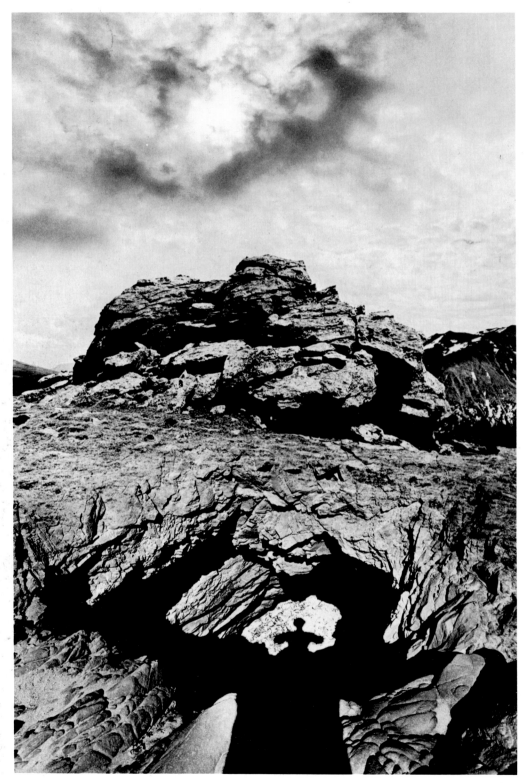

1972

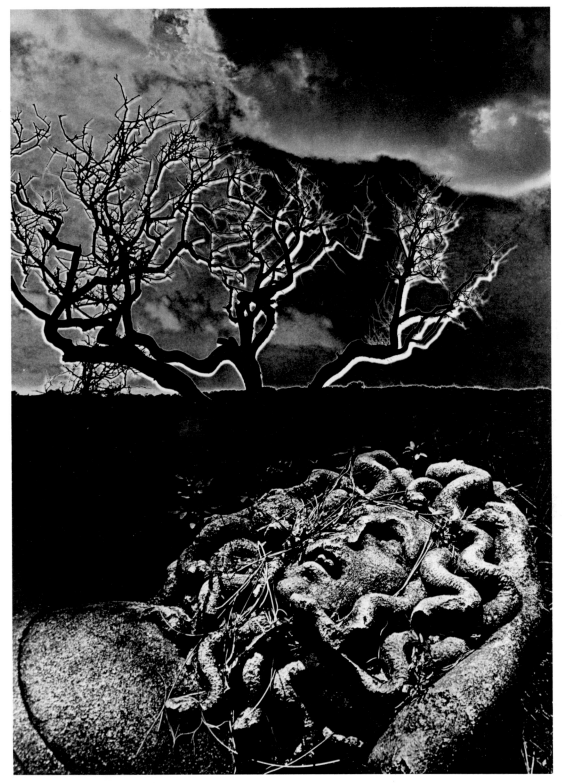

1968

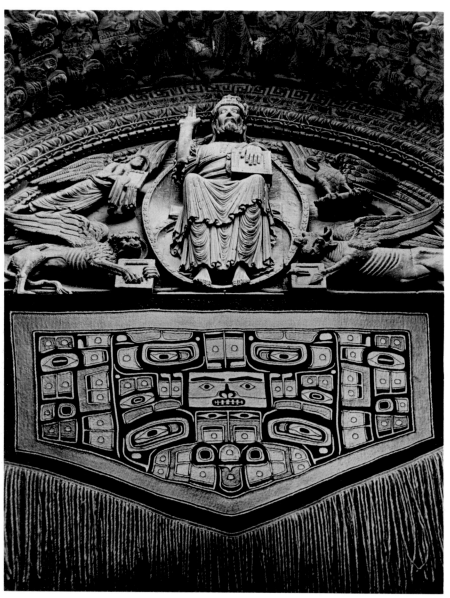

1974

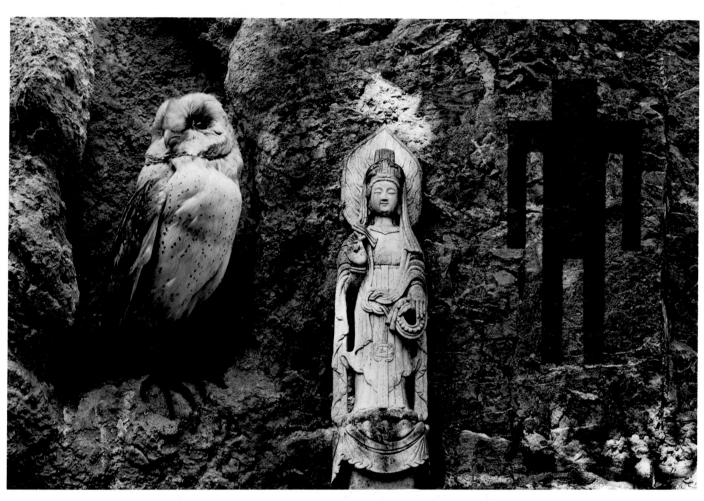

1974

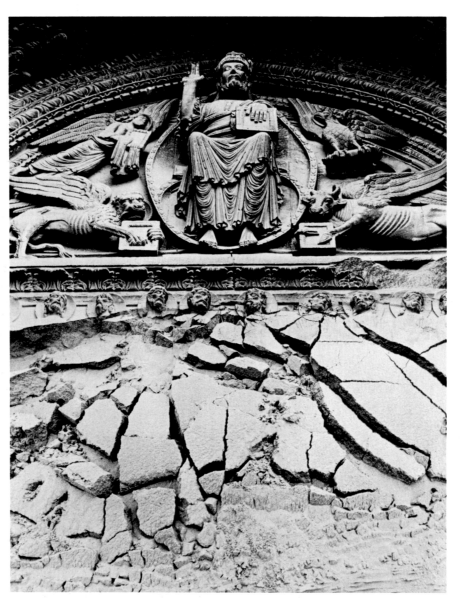

1973

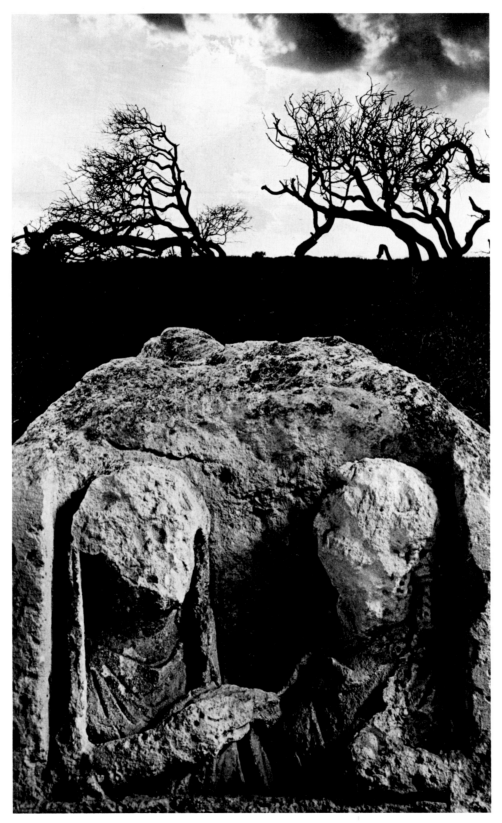

1974

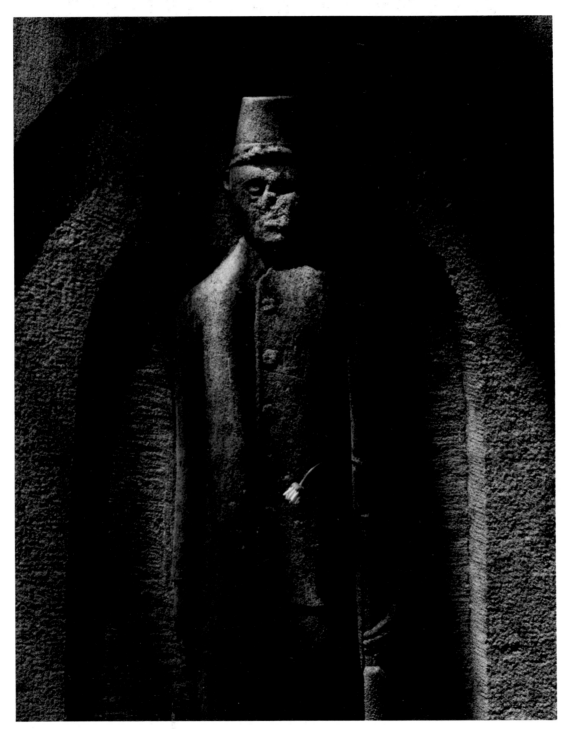

Monument to War 1959

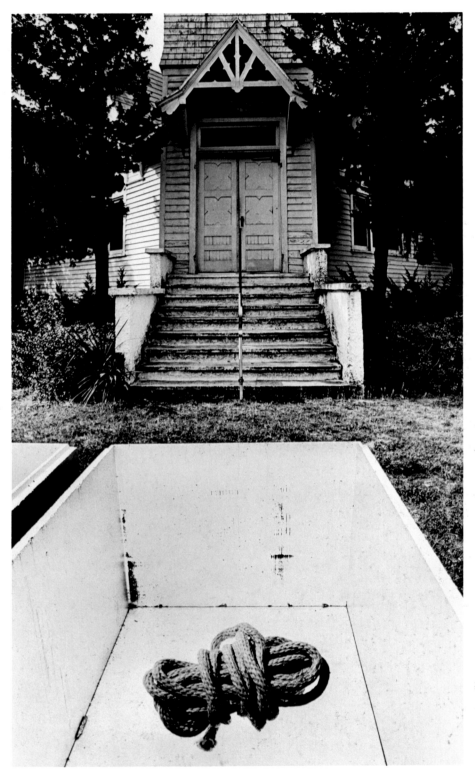

1971

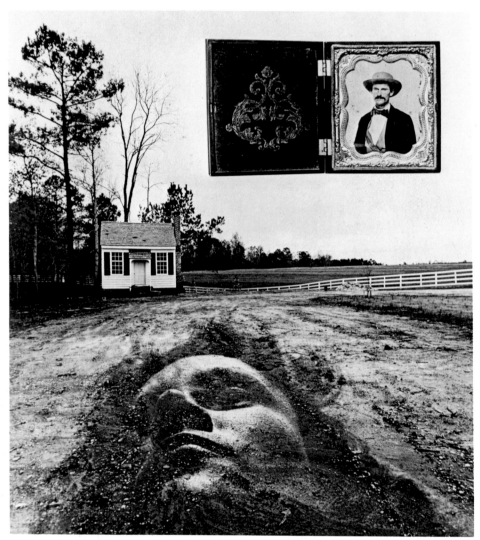

1974

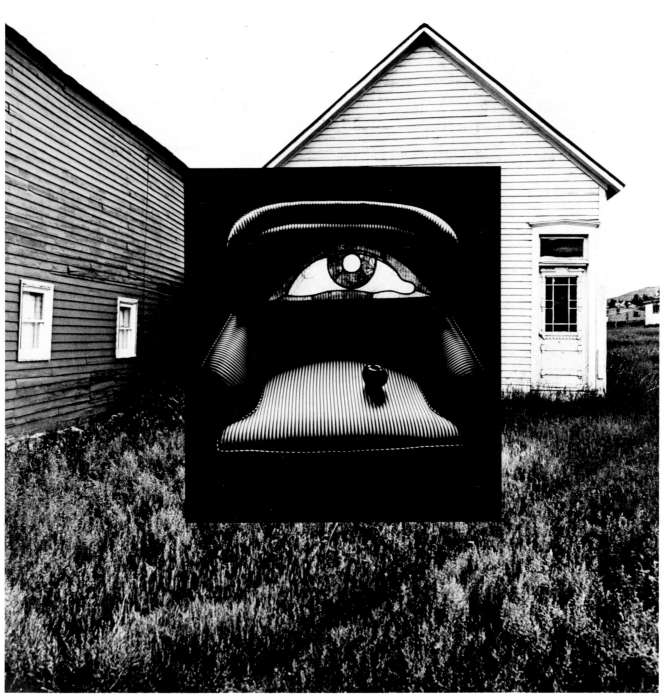

Eye Chair 1969

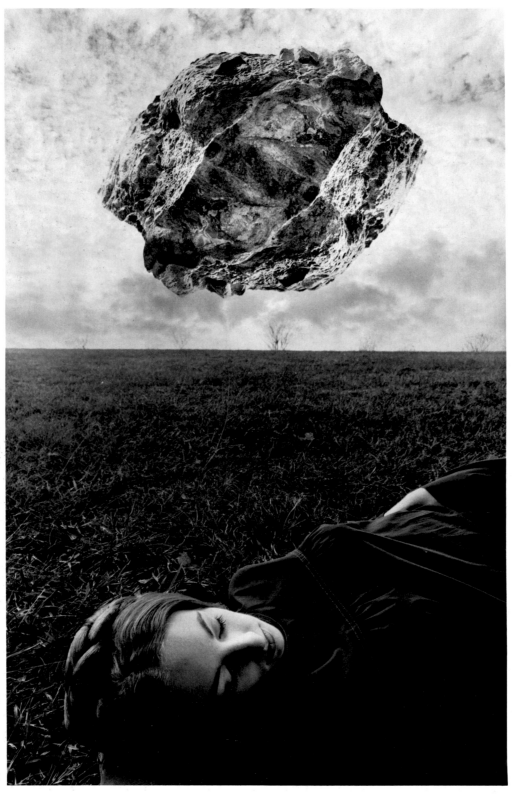

Magritte's Touchstone 1965

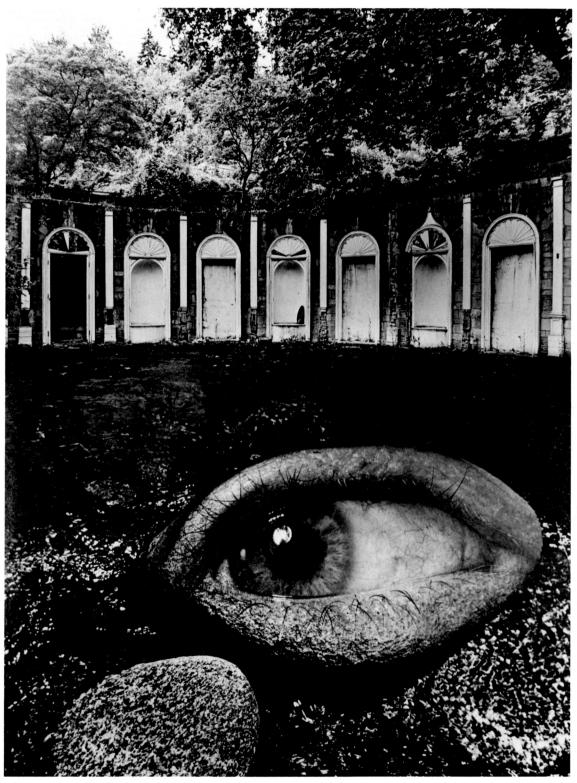

1974

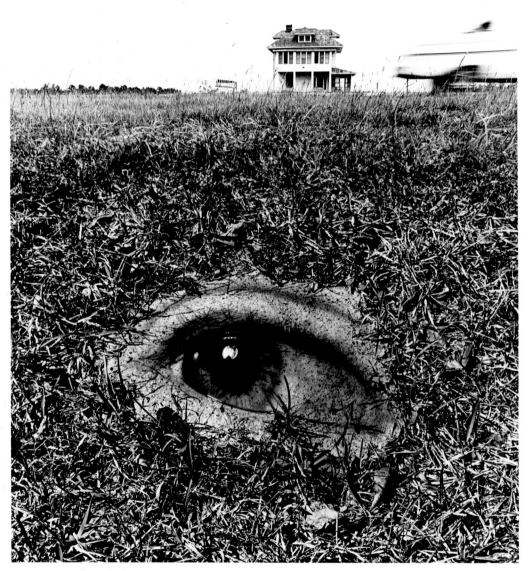

1971

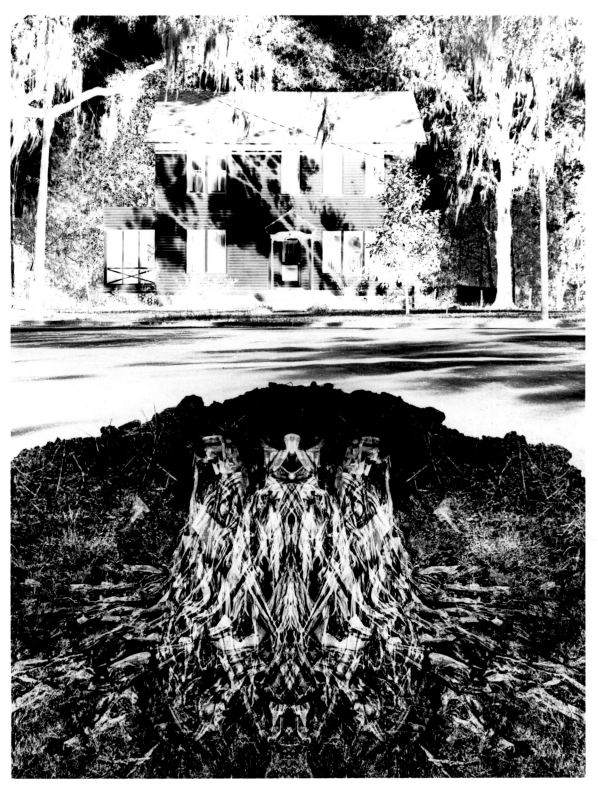

Ritual House 1965

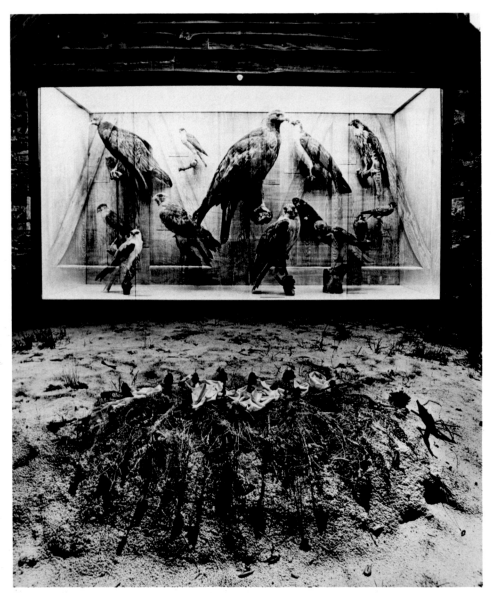

1973

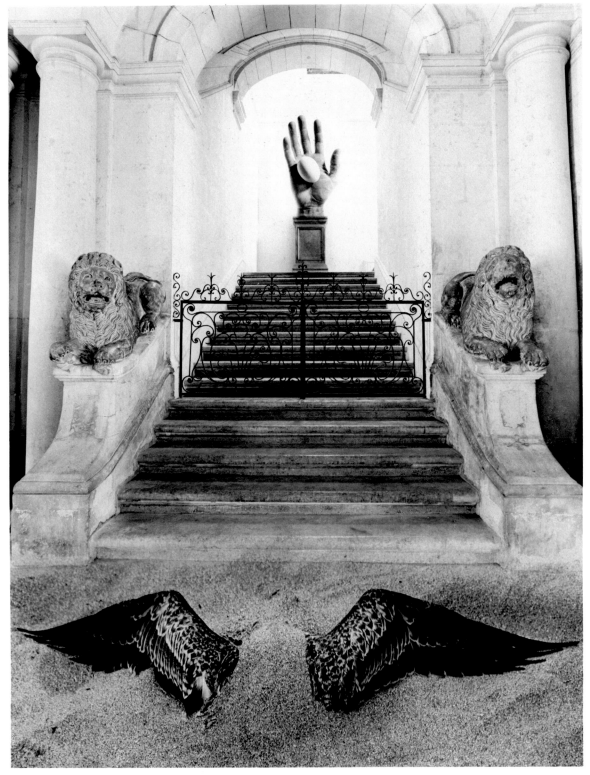

1974

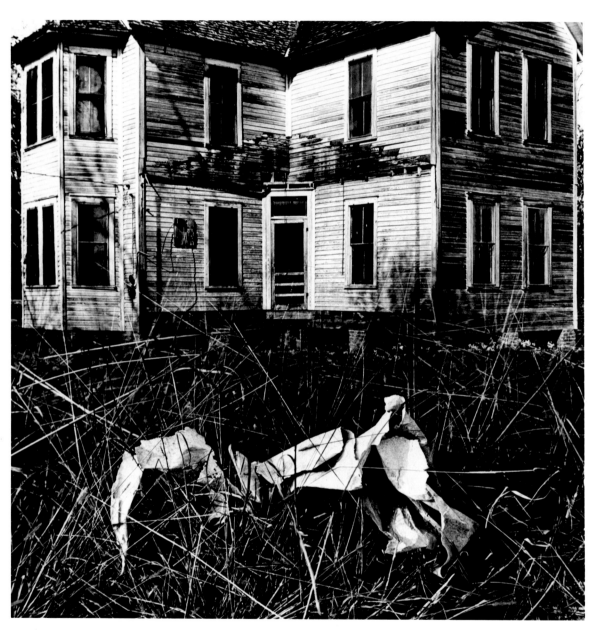

1963

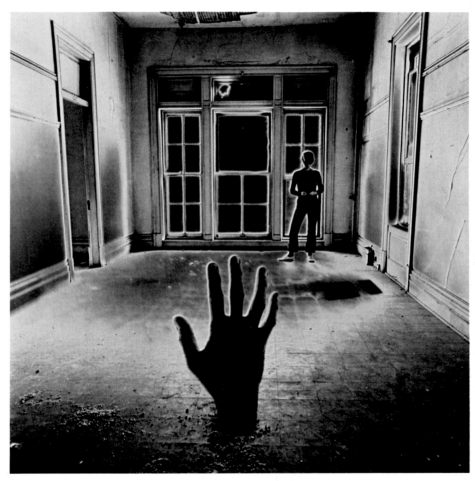

Room with Grey Light 1971

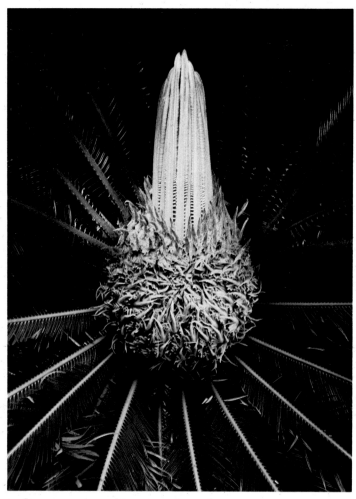

1974

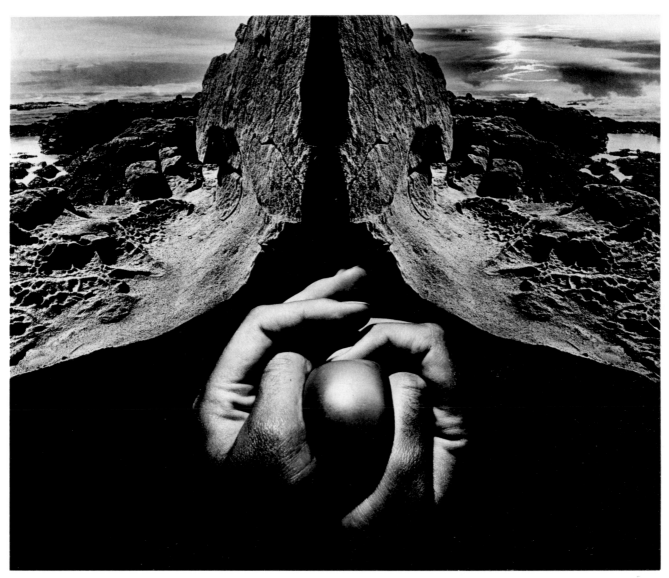

1970

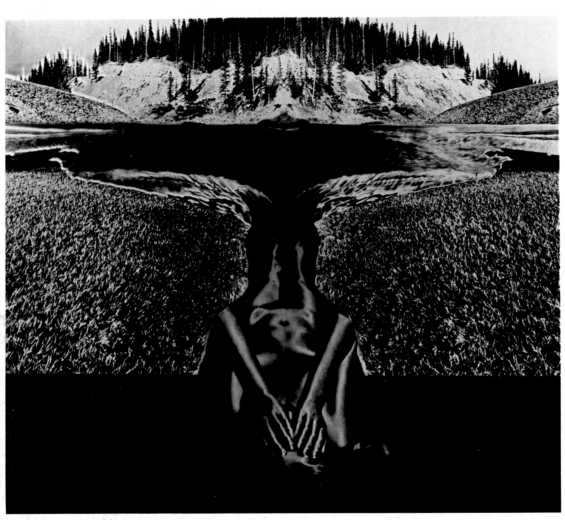

1972

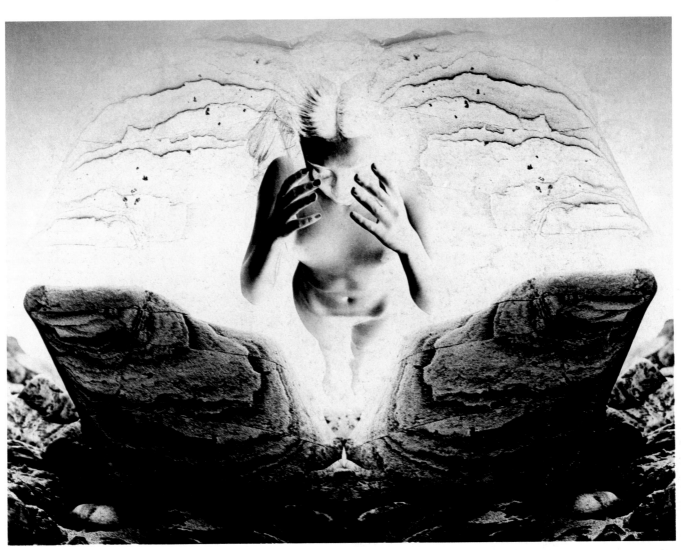

1972

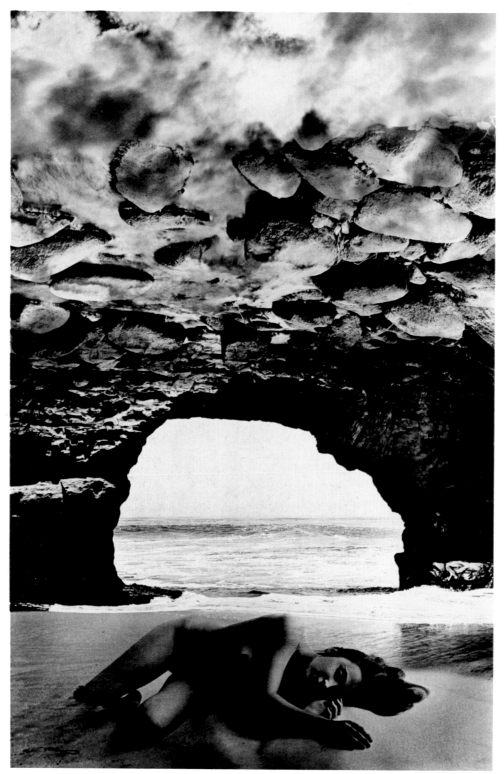

1972

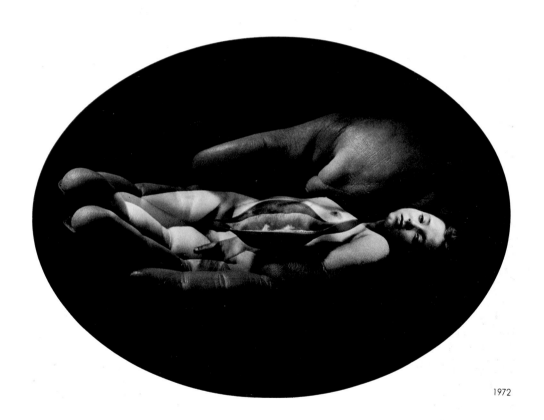

1972

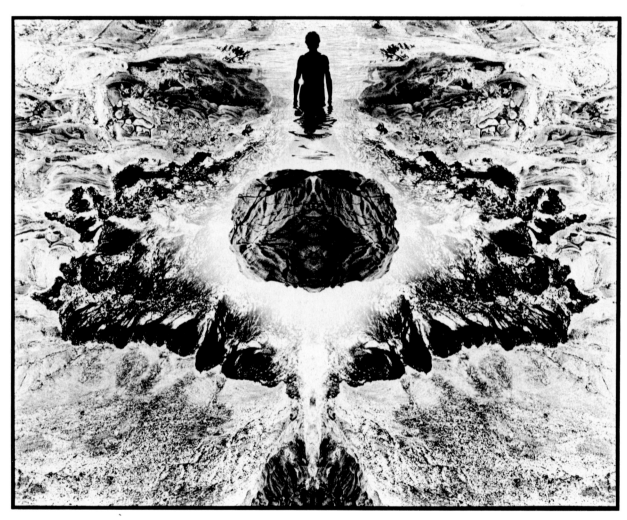

1972

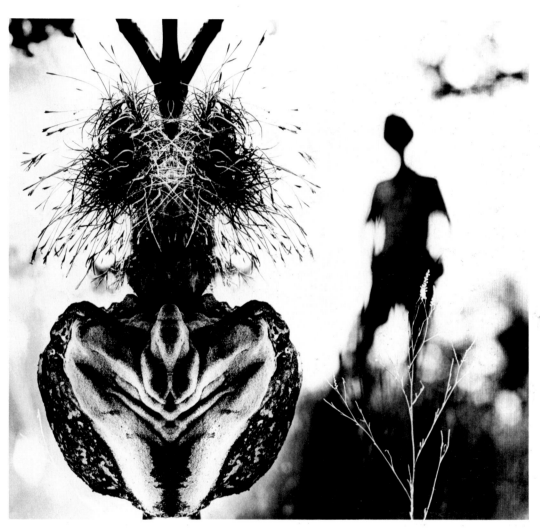

1970

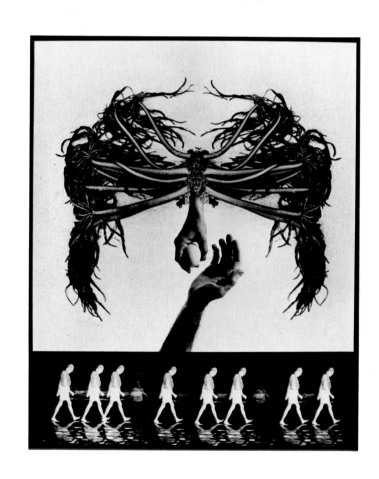

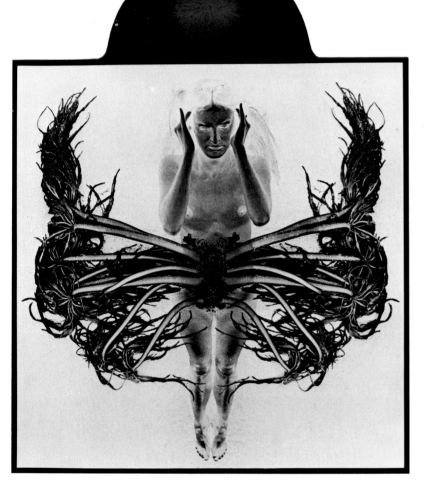
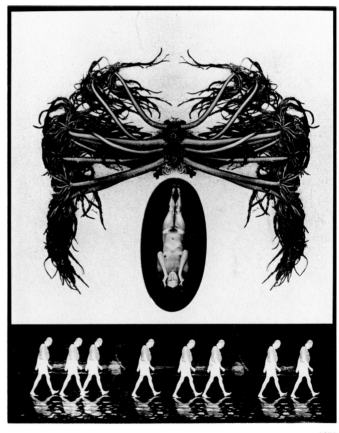

1972

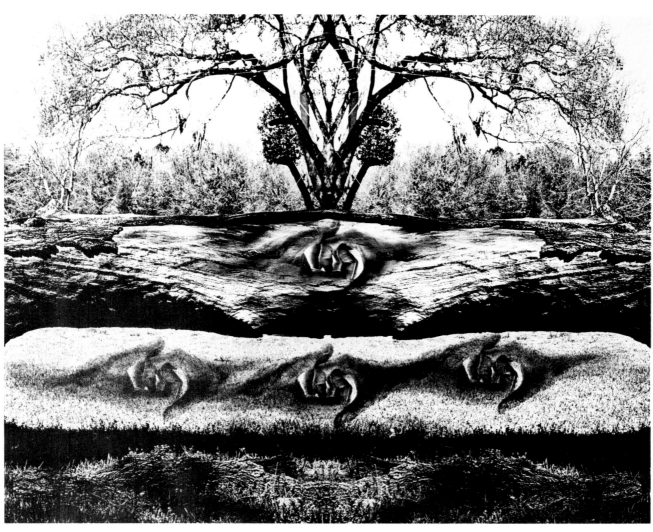

1971

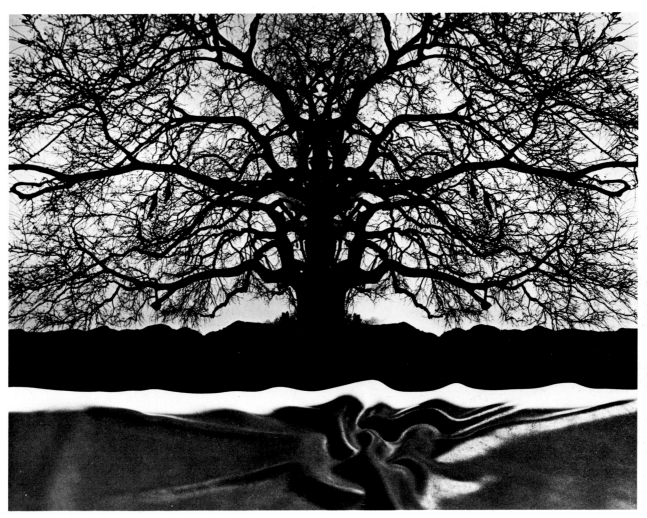

1967

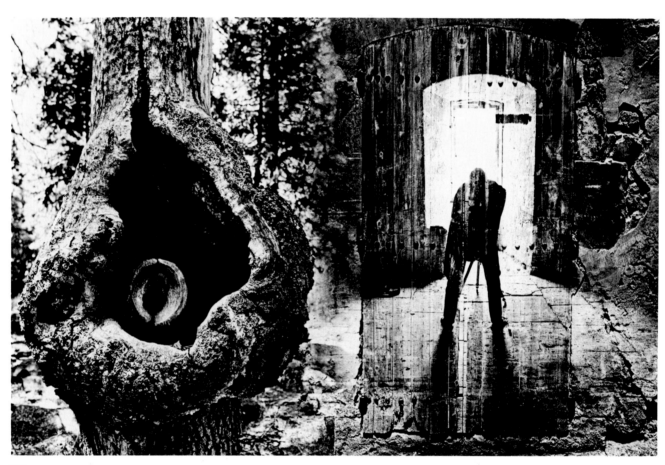

1973

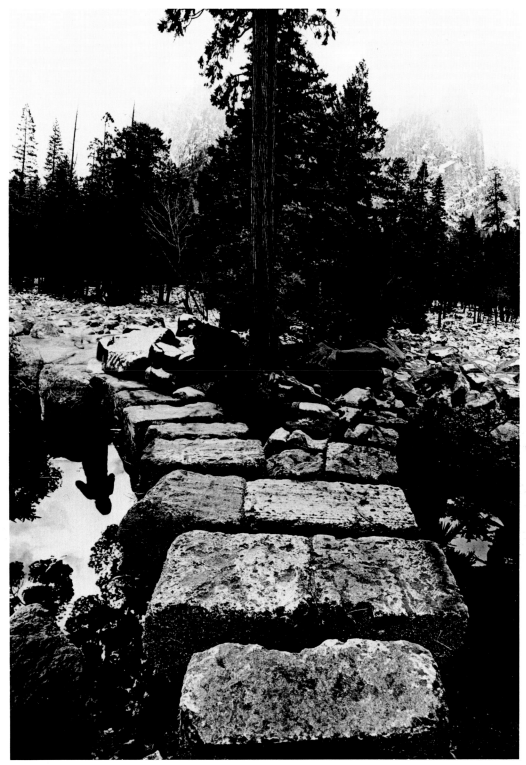

1973

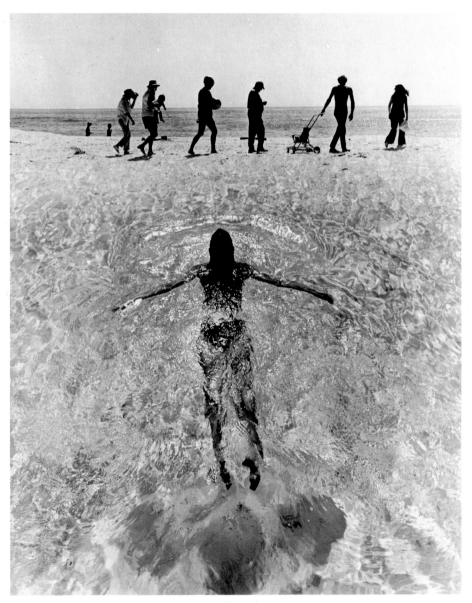

1974

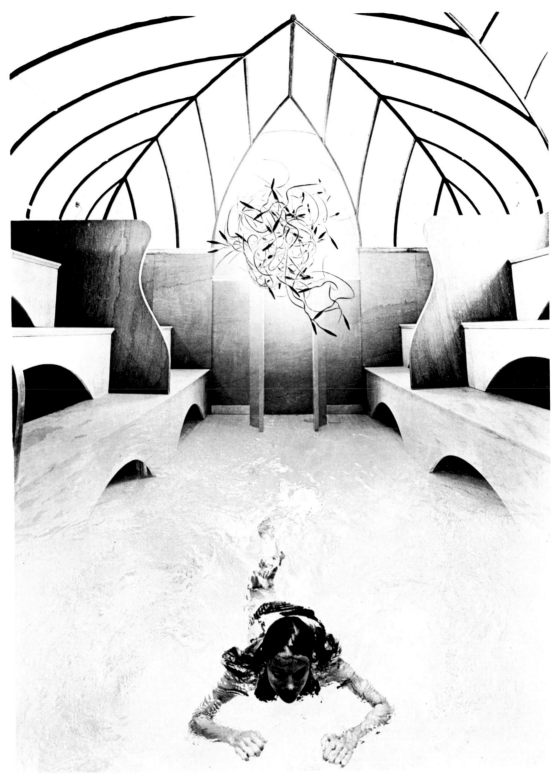

1974

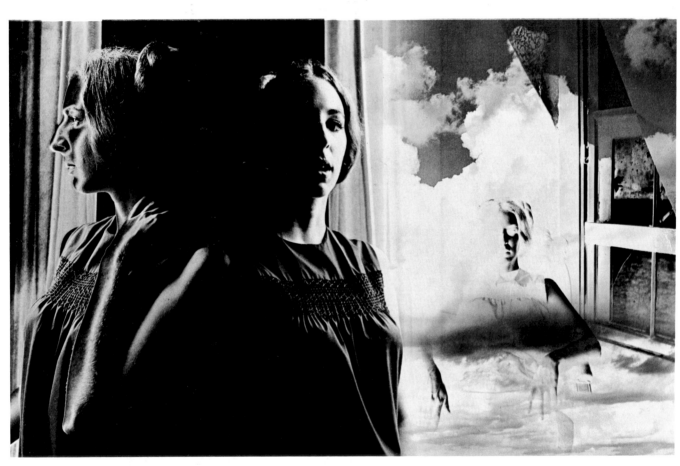

1968

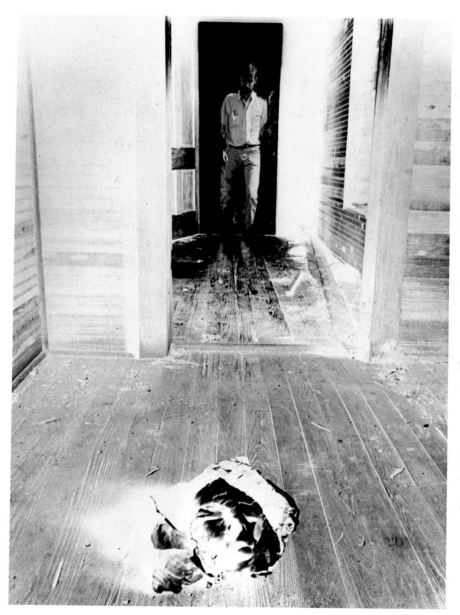

The Return 1963

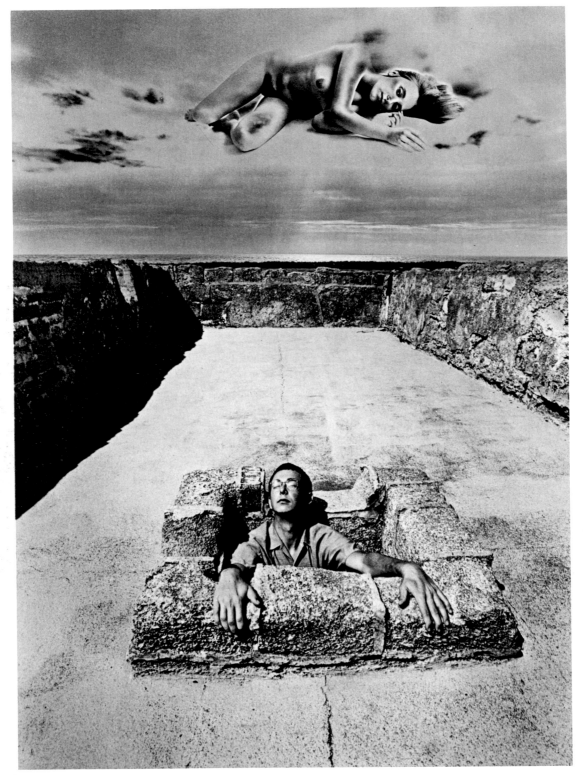

1974

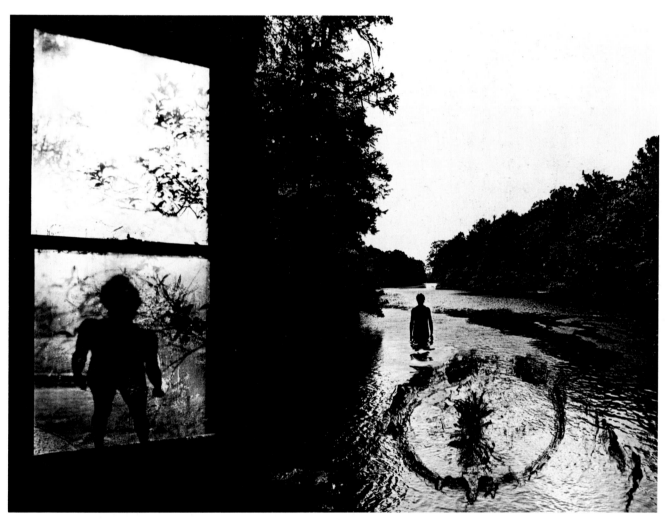

1973

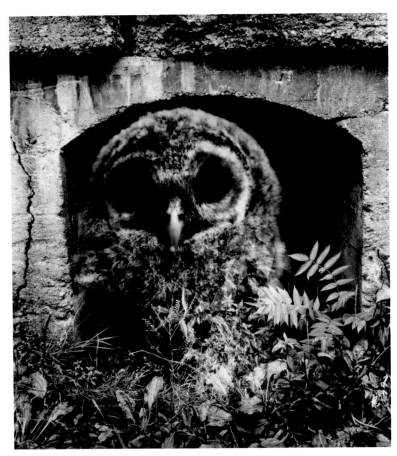

Dwelling of the Wise 1960

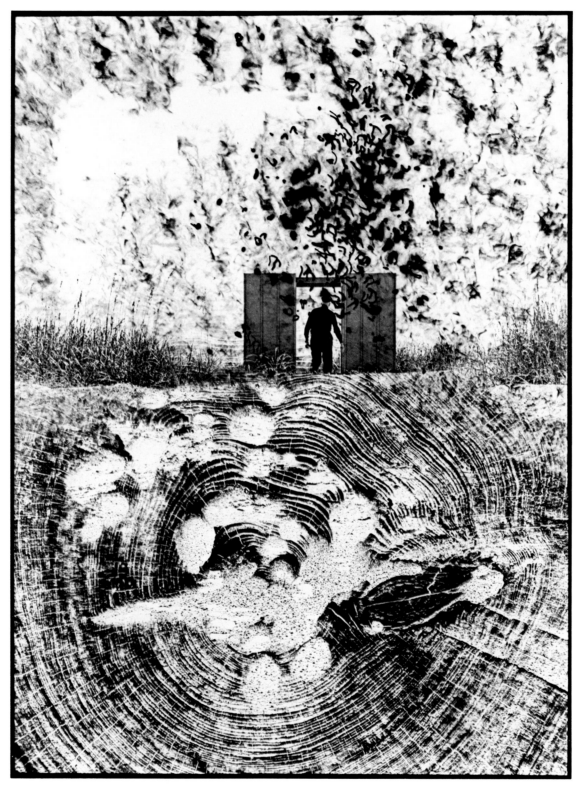

1971

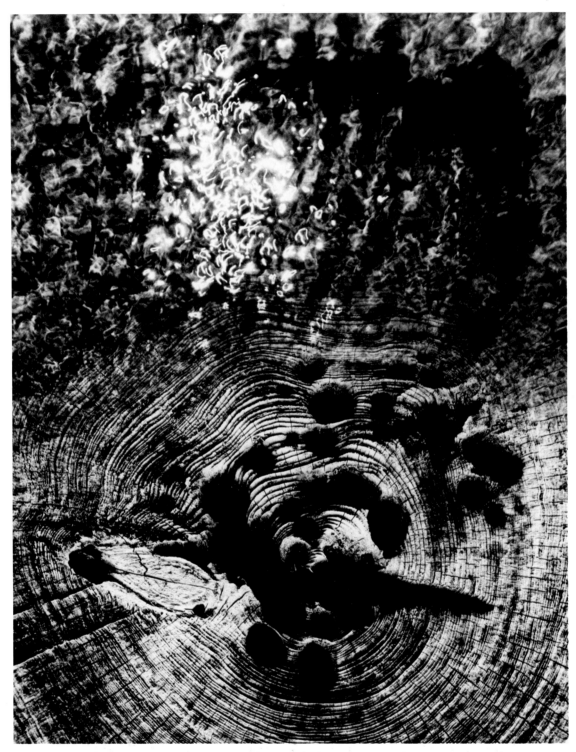

1971

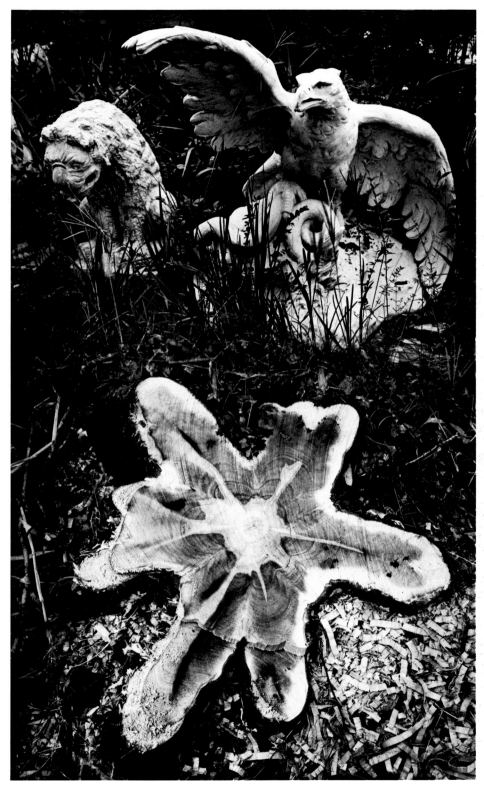

1967

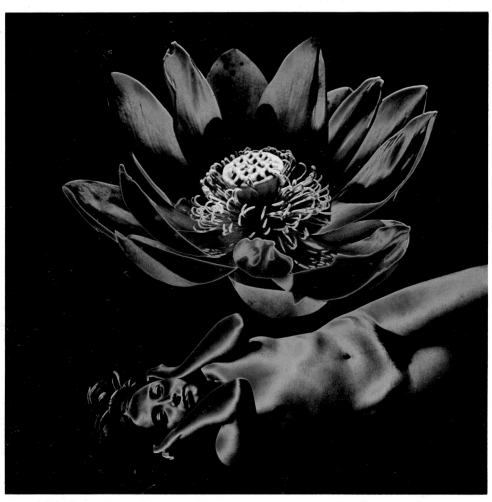

1972

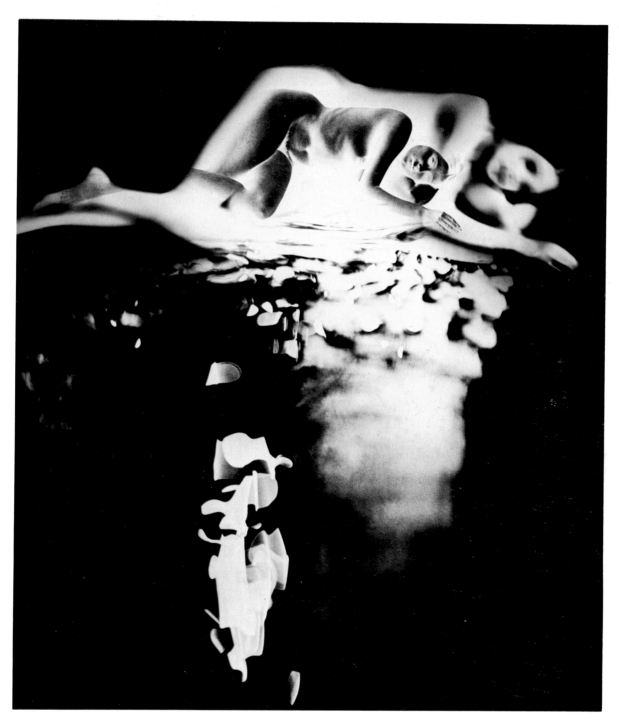

1972

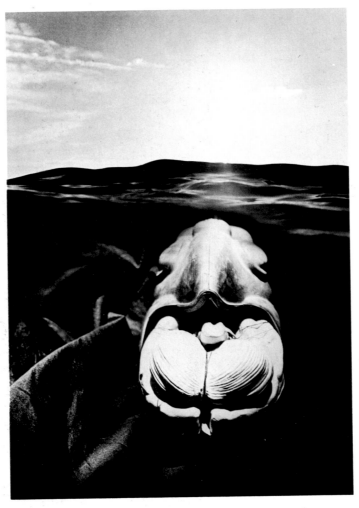

1972

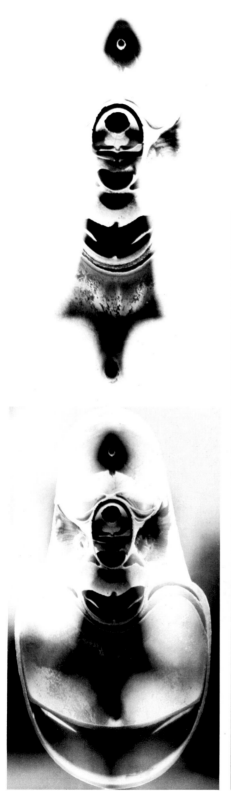
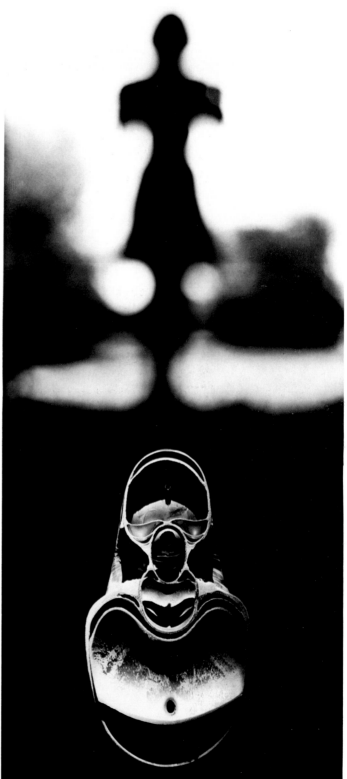

Variations on a Theme by Botticelli 1964

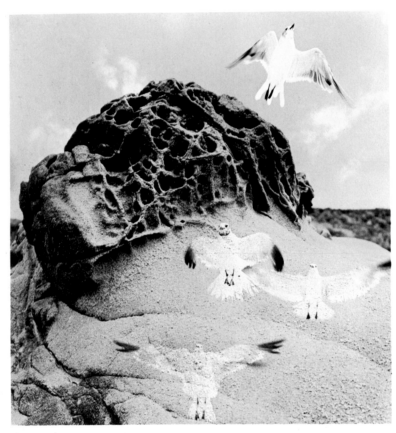

1970

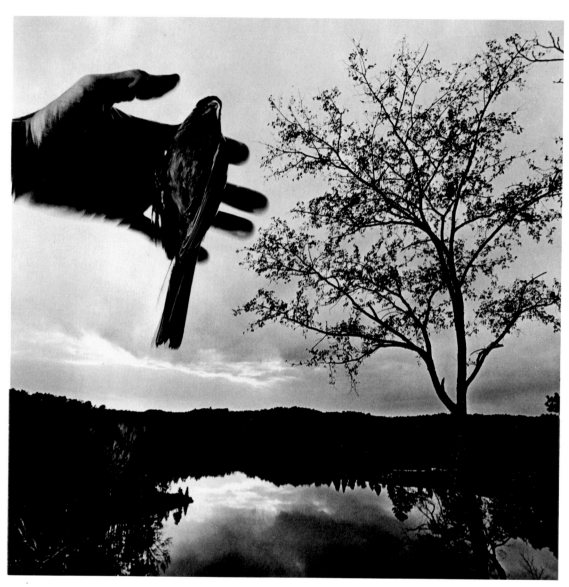

1974

CHRONOLOGY

1934 Born in Detroit, Jerry Norman Uelsmann, second son of Mr. and Mrs. Norman Uelsmann. Attends public schools. In high school develops an interest in photography.

1953 Enters Rochester Institute of Technology. Especially influenced by two faculty members, Ralph Hattersley and Minor White.

1957 Receives B.F.A. degree. Marries Marilynn Kamischke of Detroit. First published photograph in *Photography Annual 1957*. Enters Indiana University Graduate School in audio-visual communications. Graduates with M.S. degree but disillusioned with field.

1958 Transfers to the Department of Art, Indiana University and studies with Henry Holmes Smith. Graduates with M.F.A. degree in 1960.

1960 Joins the faculty of the Department of Art, University of Florida.

1962 Appointed Instructor, University of Florida. Founding member of The Society for Photographic Education; delivers paper, "The Interrelationship of Image and Technique," at the Society's first conference. First group exhibition with substantial representation, "Three Photographers," George Eastman House. Selected for "New Talent USA," *Art in America*.

1963 First major one-man exhibition at the Jacksonville Art Museum, Jacksonville, Florida.

1964 Appointed Assistant Professor, University of Florida. Exhibits with the Association of Heliographers in New York. First significant published portfolio, with an essay by Henry Holmes Smith, in *Contemporary Photographer*.

1965 Delivers paper, "Post-visualization," to The Society for Photographic Education. Completes home in Gainesville which provides proper darkroom and study facilities.

1966 Appointed Associate Professor, University of Florida. Elected to the Board of Directors, The Society for Photographic Education.

1967 One-man exhibition at The Museum of Modern Art. Awarded a Guggenheim Fellowship for "Experiments in Multiple Printing Techniques in Photography." Remains in Gainesville during fellowship period. First significant European publication of work in *Camera*.

1968 Conducts demonstration workshops and gives lectures at numerous institutions including Rhode Island School of Design, Massachusetts Institute of Technology, University of Iowa, Ohio University, Art Institute of Chicago, San Francisco Museum of Art, Purdue University, Addison Gallery of American Art, George Eastman House, The Friends of Photography, University of St. Thomas, and Wheaton College. Commissioned to create one of the "Great Ideas of Western Man" advertisements by the Container Corporation of America. Publication of William E. Parker's essay and analysis in *Aperture*.

1969 Appointed Professor of Art, University of Florida. Lectures and demonstrations at San Francisco State College, Austin College, Wheaton College, Northern Illinois University, and Florida Presbyterian College. Workshops at the Center of the Eye, Aspen, and for **The Friends of Photography**. Teaches with Ansel Adams for the first time.

1970 First large-scale retrospective exhibition at the Philadelphia Museum of Art. Publication of first monograph by Aperture, Inc. with text by Peter C. Bunnell and fables by Russell Edson. Second enlarged edition published in 1973. Lectures at Santa Fe Junior College, Ohio University, Florida Technological University, Princeton University, and New York University. Workshops at the Center of the Eye and University of California Extension, Berkeley. Cited for Special Recognition by the American Society of Magazine Photographers for outstanding contribution to photography.

1971 Delivers the fourth Bertram Cox Memorial Lecture entitled "Some Humanistic Considerations of Photography," at the Royal Photographic Society, London. The lecture is repeated in four additional cities and a partial transcript published in the *Photographic Journal*. Lectures and printmaking demonstrations at St. Lawrence University, Ringling Museum of Art, Boise State College, Idaho Art Association Conference, Image Circle, Georgia State University, and Atlanta Art Museum School. Workshops at University of Colorado, Center of the Eye, University of California Extension, Berkeley, and Imageworks. On leave from the Univeristy for the academic year under a Faculty Development Grant.

1972 Receives National Endowment for the Arts Fellowship. Lectures at Birmingham Art Museum, Stetson University, Atlanta School of Art, School of Visual Arts, Georgia Professional Photographers Association, Rollins College, and in New York for the international Fund for Concerned Photography. Workshop at Apeiron and participates in the Creative Experience Workshop under the auspices of The Friends of Photography. Portfolio of ten photographs issued by Witkin Gallery, New York.

1973 Made a Fellow of the Royal Photographic Society of Great Britain. Participates in the Fourth International Meeting of Photography, Arles, France. Lectures at University of California, Los Angeles, California Institute of the Arts, Santa Fe Junior College, Columbia College, and Lake Forest College. Conducts workshops at Columbia College, Lake Forest College, Portland State University, for the Ansel Adams Photography Workshop, and The Friends of Photography.

1974 Appointed Graduate Research Professor, University of Florida. Divorced. Receives Certificate of Merit from the Society of Publication Designers for contributions to *The New York Times*. Lectures at Cincinnati Art Museum, Colgate University, Miami-Dade Community College, Museum of Fine Arts, Boston, New Orleans Museum of Art, and Southwest Missouri State University. Conducts a telephone lecture to photography master classes, University of Wisconsin, Madison. Conducts workshops at Loch Haven Art Center, Northern Kentucky State College, Southwest Missouri State University, and for the Ansel Adams Photography Workshop.

1975 Marries F. Diane Farris. Elected Advisory Trustee, The Friends of Photography. Receives Certificate of Excellence from American Institute of Graphic Arts for contributions to *The New York Times*. Lectures at High Museum, Atlanta, and Speed Museum, Louisville.

ONE-MAN EXHIBITIONS

BIBLIOGRAPHY
Publications By And About With Quoted Remarks

"A Portfolio of Fun Pix" (Letter to Fred Parker). *Untitled*,
2/3:77-86 (1972). Statement on Creative Experience Workshop.
Beadleston, Suzi, "Takes 'Special Effects' Seriously." *The Gainesville
Sun*, October 22, 1966, n.p. Various quoted remarks.
Busch, Ralph, "5 Pros Pick Their Favorite B & W Films and
Developers." *Popular Photography*, 75:96-101 (August, 1974).
Statement on exposure and development techniques.
"Challenging the Traditions," *The Art of Photography*.
Richard L. Williams, ed., New York, Time-Life Books, 1971,
pp. 152-153. Statement on working methods.
Deschin, Jacob, "What They're Teaching Today."
35 MM Photography, Winter: 42-47 (1971). Statements on
teaching, largely misquoted.
"Gallery." *Life*, 67:8-11 (November 21, 1969). Untitled statement
on the darkroom.
Gaskins, W.G., "The American Scene." *Spectrum*,
Spring: 10-11 (1971). Statement on Teaching.
Gautrand, Jean-Claude, "Jerry N. Uelsmann." *Photo-Revue*,
Fevrier: 66-75 (1974). Reprinted in *Nueva Lente*, 27:41-54
(Mayo, 1974). Interview.
Great Ideas of Western Man. Chicago, Container Corporation
of America, 1968 (Presentation Piece). Statement on the
photograph commissioned for the series.
"Heliographers." *Photography Annual 1965*. New York,
Ziff-Davis Publishing Co., 1964, p. 197. Untitled statement on
personal approach to photography.
Into the 70's. Akron, Akron Art Institute, 1970. Untitled
statement on the darkroom.
"Jerry N. Uelsmann." *Camera*, 46:6-19 (January, 1967).
Excerpts from "Post-visualization" and an autobiographical essay.
"Jerry N. Uelsmann." *The Professional Photographer*, 94:96
(July, 1967). Untitled statement on personal approach to
photography.
Kemp, Weston, *Photography for Visual Communicators*.
Englewood Cliffs, Prentice-Hall, Inc., 1973, p. 214. Statement or
personal approach to photography.
Kinzer, H.M., "Jerry Uelsmann: 'involved with the celebration
of life'." *Popular Photography*, 57:136-143, 177-181
(November, 1965). Various quoted remarks.
"Shoot Now—Think Later." *Popular Photography*,
58:65, 101 (May, 1966). Excerpts from "Post-visualization."
Lyons, Nathan, "The Younger Generation." *Art in America*,
51:76 (December, 1963). Untitled statement on
personal approach to photography.
Martin, Eunice Tall, "Jerry Uelsmann's World of Photography."
Floridalumnus, 20:14-20 (Winter, 1968). Various quoted remarks.
"The Multiple Print." *The Camera*, Robert G. Mason and
Norman Snyder, eds., New York, Time-Life Books, 1970, p. 44.
Untitled statement on personal approach to photography.
"New Talent USA." *Art in America*, 50:49 (No. 1, 1962).
Untitled statement on personal approach to photography.
Parker, William E., *Eight Photographs: Jerry Uelsmann*. New York,
Doubleday & Company, Inc., 1970. Various quoted remarks.
"Uelsmann's Unitary Reality." *Aperture*, 13:n.p., (No. 3,
1967 [1968]). Various quoted remarks.
"Photography." *Newsweek*, 84:68 (October 21, 1974).
Untitled statement on use of the camera.
"Photography Boom or Bust?" *Photography Year 1974*.
Sheldon Cotter, ed., New York, Time-Life Books, 1974, pp.
156-157. Statement on teaching.
Photography Workshop/Summer 1970. Berkeley, University
Extension, University of California, 1970 (Poster
announcement). Untitled statement on post-visualiztion.
Scarbrough, Linda, "New Breed Foto Show at Modern Museum."
New York Daily News, February 26, 1967, p. F2M. Statement on
photography in relation to the arts of the nineteenth
century and today.
Six Photographers 1965. Urbana, University of Illinois, 1965.
Untitled statement on personal photography.
"Three Photographers Exhibition." *Image*, 11:17-18 (No. 4, 1962).
Untitled statement on personal approach to photography.
12 x 12. Providence, Carr House Gallery, Rhode Island

School of Design, 1970. Untitled statement on the darkroom.

Uelsmann, Jerry N., "Fourth Bertram Cox Memorial Lecture: Some Humanistic Considerations of Photography." *The Photographic Journal*, 111:165-182 (April, 1971). Numerous inaccuracies in transcript.

"Interrelationship of Image and Technique." *Invitational Teaching Conference at The George Eastman House*, Nathan Lyons, ed., Rochester, The George Eastman House, 1963, pp. 90-95. Reprinted in *Memo*, 1:185-187 (November, 1964).

Jerry N. Uelsmann. New York, Aperture, Inc., 1970. Introduction by Peter C. Bunnell, Fables by Russell Edson, with comprehensive bibliography through 1970. Second edition, enlarged with updated chronology, 1973.

Jerry N. Uelsmann Portfolio. Roslyn Heights, Witkin-Berley, Ltd., 1972. Introduction by Robert Fichter. Portfolio of ten original photographs.

Portfolio of Photographers & Letter:

I have Long Been Nourished by Enigma." *Untitled*, 7/8:47-57 (1974).

"Post-visualization." *Florida Quarterly*, 1:82-89 (Summer, 1967). Reprinted in *Creative Camera*, 60:212-219 (June, 1969). Reprinted in *Contemporary Photographer*, 5:n.p. (No. 4, 1967 [1970]).

"Some Humanistic Considerations of Photography." *The Photographic Journal*, 111:117-119 (March, 1971). Reprinted in *Afterimage*, 1:6 (March, 1972). Reprinted in *Le Nouveau Photocinema*, 15:22-30, 76 (Juillet-Aout, 1973).

"Wynn Bullock/Tracing the Roots of Man in Nature." *Modern Photography*, 34:89 (May, 1970).

White, Minor, ed., "Special Supplement in Honor of the Teaching Conference Sponsored by George Eastman House of Photography 1962." *Special Supplement Volume II* (to *Aperture*), 1963, pp. 7-8. Statement on commitment to teaching photography.

Selected Publications About

Bry, Michael E., "Gallery Snooping." *Modern Photography*, 33:34, 36 (November, 1969). "Gallery Snooping." *Modern Photography*, 34:32 (October, 1970).

Bunnell, Peter C., "Photography as Printmaking." *Artist's Proof*, Fritz Eichenberg, ed., New York, Pratt Graphics Center, 1969, pp. 24-40.

Coleman, A.D., "He Captures Dreams, Visions, Hallucinations." *The New York Times*, January 3, 1971, p. D14.
"Latent Image." *Village Voice*, September 26, 1968, p. 20.
"Latent Image." *Village Voice*, February 18, 1971, p. 16.
"Latent Image." *Village Voice*, April 20, 1972, p. 31.

"Creative Photography Display Set Up At IU." *Bloomington Herald-Tribune*, April 4, 1959, n.p.

Craven, George, *Object and Image*. Englewood Cliffs, Prentice-Hall, Inc., 1975, pp. 180, 188-190.

Deschin, Jacob, "Color, Candids, Novelty." *The New York Times*, November 22, 1964, p. x17.
"Finding Pictures in the Darkroom." *The New York Times*, February 19, 1967, p. D30.
"Group Exhibit." *The New York Times*, July 26, 1964, p. x16.
"Jerry Uelsmann at The Witkin." *The Photo Reporter*, 2:6-7 (April, 1972).
"Pictures on View." *The New York Times*, January 26, 1964, p. x23.

Fox, Phyllis, "I Celebrate My Life Through Photography." *Aspen Illustrated News*, July 30, 1969, pp. 7-9.

Gaskins, W.G., "Photography and Photographic Education in the U.S.A." *Image*, 14:8-13 (December, 1971).

Gassan, Arnold, *A Chronology of Photography*. Athens, Handbook Company, 1972, pp. 41, 121, 209.

"Gros Plan." *France Photographie*, 38:17-24 (Novembre, 1974).

Harker, Margaret F., "Sense and Perception." *The Photographic Journal*, 108:125-147 (May, 1968).

Hattersley, Ralph, "Games Photographers Play," *Photography Annual 1968*. New York, Ziff-Davis Publishing Co., 1967, pp. 14-30, 186, 191.

"Heliographers," *Photography Annual 1965*. New York, Ziff-Davis Publishing Co., 1964, pp. 106-111, 197.

"The Heliographers... a New Photographic Movement." *U.S. Camera and Travel*, 27:61-65 (May, 1964).

Hollyman, Tom, "In 1970, We Honor..." *Infinity*, 19:5-23 (September, 1970).

Howell, Chauncey, "Art, etc." *Women's Wear Daily*, March 2, 1967, p. 28.

"The Impact of Multiple Images." *The Print*. Robert G. Mason, ed., New York, Time-Life Books, 1970, pp. 214-219.

"Jerry Uelsmann." *Infinity*, 11:22-26 (May, 1962).

Keim, Jean-A., *Histoire de la Photographie*. Paris, Presses Universitaries de France, 1970, p. 117.

Kramer, Hilton, "Portrait Photographs — A Historical Collision." *The New York Times*, September 14, 1969, p. D27.

Lyons, Nathan, ed., *The Persistence of Vision*. New York, Horizon Press, 1967.

Parker, William E., "Notes on Uelsmann's Invented World." *Infinity*, 16:1, 4-13, 32-33 (February, 1967).

Scully, Julia, "Seeing Pictures." *Modern Photography*, 39:16 (June, 1975).

Smith, Henry Holmes, ed., *Photographer's Choice*. Bloomington, Henry Holmes Smith, 1959.
"The Photography of Jerry N. Uelsmann." *Contemporary Photographer*, 5:47-71 (No. 1, 1964).

"Special Issue on Photographic Education: University of Florida." *Infinity*, 18:16-19 (April, 1969).

"Le surréalisme on photographie." *Techniques Graphiques*, 68:n.p. (1967).

Szarkowski, John, *Jerry N. Uelsmann*. New York, The Museum of Modern Art, 1967. Essay reprinted in *Jerry N. Uelsmann*. Phoenix College, 1968.

Thornton, Gene, "Uelsmann: Does He See Ghosts?" *The New York Times*, April 16, 1972, p. D23.

"Toning Black-and-White Images," *Color*. Robert G. Mason, ed., New York, Time-Life Books, 1970, p. 222.

Ward, John L., *The Criticism of Photography as Art: The Photographs of Jerry Ulesmann*. Gainesville, University of Florida Press, 1970.

White, Minor, "The Persistence of Vision." *Aperture*, 13:59-60 (No. 4, 1968).

Williams, Hiram, "Five from Florida." *Art in America*, 50:132 (Summer, 1962).

Zucker, Harvey, "Multiple Images." *Popular Photography*, 62:112-115, 130 (June, 1968).

A single asterisk (*) indicates that the exhibition was circulated by the institution listed. A double asterisk (**) indicates that the exhibition was organized by the institution listed for circulation only. Entries for circulating exhibitions have not been listed beyond the location where the exhibition was first shown. All information is thru June, 1975. Thanks are extended to William Drenttel for assistance with the bibliography. —Peter C. Bunnell